POSTCARD HISTORY SERIES

Along the Bucktail Highway

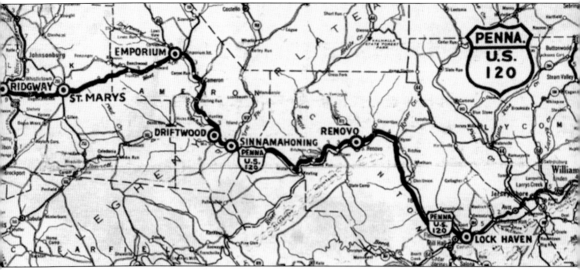

Pictured here is the Bucktail Highway region, along with its key hubs as considered in this book. This map is from a postcard folder that was postmarked in 1945 and features images from the Bucktail Highway.

On the front cover: Please see page 97. (Author's collection.)

On the back cover: Please see page 98. (Author's collection.)

POSTCARD HISTORY SERIES

Along the Bucktail Highway

Charles E. Williams

ARCADIA
PUBLISHING

Published by Arcadia Publishing
Charleston SC, Chicago IL, Portsmouth NH, San Francisco CA

Printed in the United States of America

Library of Congress Catalog Card Number: 2007930185

For all general information contact Arcadia Publishing at:
Telephone 843-853-2070
Fax 843-853-0044
E-mail sales@arcadiapublishing.com
For customer service and orders:
Toll-Free 1-888-313-2665

Visit us on the Internet at www.arcadiapublishing.com

Dedicated to Kim, Tara, and Kelsey
and to our new friend, Owen, the Boykin spaniel

CONTENTS

ACKNOWLEDGMENTS

I thank my family, friends, and colleagues who have supported my work on the history and ecology of northern Pennsylvania landscapes over the years. I especially give heartfelt thanks to my wife, Kim, and our daughters Tara and Kelsey. Their support, encouragement, and understanding made this book possible.

Finally, I extend my thanks to the folks at Arcadia Publishing, especially senior editor Erin Vosgien, for their patience, encouragement, and support.

All postcards in this book are from the author's collection.

INTRODUCTION

Why write about a highway? Many of us spend a good part of our lives on the road, commuting to work, sitting in traffic, looking for the quickest way to get from place to place without attracting the attention of the highway patrol. We seek to minimize our time on the highway and invest it where it truly matters: family, home, work, or play.

But not all highways are the same. Some are more than a line on the map or a commuter's time sink—they are a destination and an experience. Some highways are corridors not just in space but in time, taking us from town to town as we expect but also transporting us back to the past—something perhaps we did not expect. Combine this lesson in history with the visual sensation of scenic landscapes, winding rivers, and deep forests and the drive becomes an event, one to be savored and appreciated.

Pennsylvania's Bucktail Highway, State Route 120, is such a road, and traveling it is a worthwhile event. Historian Thomas T. Taber III, a student of the region's logging railroads, describes his experience driving a portion of the Bucktail Highway in 1972. "The fifty mile drive from Lock Haven thru Clinton County toward Sinnemahoning is one of the most scenic, pleasant rides in Pennsylvania. Almost, but not quite, unspoiled by bill boards, hamburg stands, and beer joints, the highway curves, rises and falls to an ascending series of changing views in the lovely Susquehanna Valley." Little has changed along the Bucktail Highway over the 35 years since Taber wrote this passage.

In total, the Bucktail Highway traverses 120 miles of Pennsylvania's scenic and historic north-central tier of counties, linking Ridgway in the west with Lock Haven to the east. Crossing the eastern continental divide just east of St. Marys, the Bucktail Highway closely follows the deep, sometimes twisting valleys carved by the Driftwood Branch, Sinnemahoning Creek, and the West Branch of the Susquehanna River. Once a Native American path, the Sinnemahoning Trail, the valley carried settlers west through a bounty of forests, fish, and game, along a road that eventually became known as the Bucktail Trail.

The road and the region, sometimes called the Bucktail Mountains, were named after the famed Bucktail Regiment of the Civil War, whose recruits wore a buck's tail on their hats as a regimental badge. The Bucktails, volunteers mainly from Cameron, Elk, and McKean Counties, were accomplished sharpshooters who departed for the war from Driftwood on Sinnemahoning Creek in April 1861 via raft to Harrisburg. A bronze monument at the site commemorates their departure.

The main hubs of the Bucktail Highway—Ridgway, St. Marys, Emporium, Renovo, and Lock Haven—became commercial and industrial centers of the region. Extractive industries, focused on timber, tanbark, coal, and clay, arose at an early date and boomed when railroads entered

the region in the 1850s and 1860s. By the early 1900s, the timber, clay, and coal industries had waned and manufacturing industries—engine factories, silk mills, and carbon and powdered metal plants—filled the gap.

The tourism industry also arose in the early 1900s, stimulated by Henry Ford's automobile, which would further transform the region. Growth of leisure time, and a desire to escape from the workweek, found many a family on an automobile tour of the countryside. To meet this recreational demand, the Commonwealth of Pennsylvania created Bucktail State Park in 1933. Legislative Act 301 creating the park reads,

> That the Commonwealth of Pennsylvania hereby dedicates to the public, for use as a park and pleasure ground for the benefit and enjoyment of the people, all that area of land extending in length from the western city line of Lock Haven, in Clinton County, to the eastern borough line of Emporium, in the County of Cameron, and along the course of the western branch of the Susquehanna River, and its tributary, Sinnemahoning Creek, in Clinton and Cameron counties, an estimated distance of 75 miles, and in width from mountain rim to mountain rim across the valley. The said park shall be called and known as the "Bucktail State Park," in commemoration of the Bucktail Regiment which embarked from Driftwood, in Cameron County, in April, 1861, upon rafts of their own construction to hasten their arrival at the imperiled State Capitol.

The park, as created by the act, stretches 75 miles along the Bucktail Highway from Lock Haven to Cameron County and includes over 21,000 acres of parkland as well as other state and private lands within its legislative boundary. Twenty-seven state parks occur within a 30-mile radius of the Bucktail Highway, and several hundred thousand acres of state forest lands cover the mountainous landscape. Today the Bucktail Highway is a centerpiece of the Pennsylvania Wilds, a state-supported initiative to promote tourism while conserving the unique natural resources of the region.

My aim in writing this book was to provide snapshots of the history, culture, and environment of the Bucktail Highway that a traveler or tourist may find useful when visiting the region. As in my previous books on the Allegheny River, I use vintage postcards to provide a window into the past. The book is organized geographically with major towns or groups of villages as chapters. As a western Pennsylvanian, I have chosen to follow the Bucktail Highway east beginning at Ridgway and ending in and around Lock Haven. There is no reason that the order cannot be reversed.

Chance favors the prepared mind, and I hope this book will provide travelers, tourists, and others a means to help interpret, and put in perspective, things they see and experience on and around the Bucktail Highway. Perhaps Thomas T. Taber III says it best: "Armed with a knowledge of the past, we find the drive up the valley a memorable event. Not only can we enjoy the beauty, but we can also comprehend the vast change that has occurred since the turn of the century—change that runs counter current to the trend in most of the United States."

Welcome to the Bucktail Highway.

One

RIDGWAY

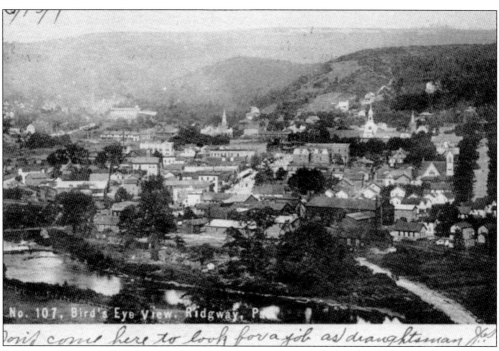

Ridgway, the seat of Elk County, is the western gateway of the Bucktail Highway. Founded in the 1820s and named for Jacob Ridgway, a Philadelphia Quaker, Ridgway's early growth was spurred by the abundant lumber of the region. This bird's-eye view of Ridgway, postmarked 1907, shows a view of the town looking east from the Clarion River. The message written on the card's front reads, "Don't come here to look for a job as a draughtsman."

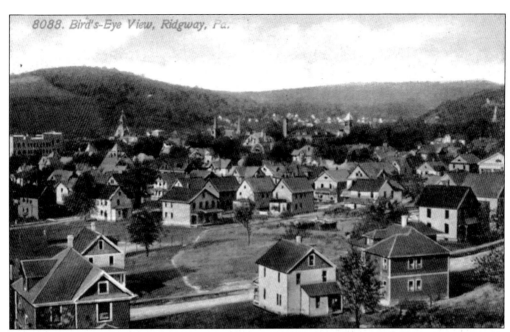

8088. Bird's-Eye View, Ridgway, Pa.

This card shows a bird's-eye view of Ridgway looking north toward Elk Creek from the residential area at the lower end of town. In the early 1900s, Ridgway had a population of about 6,700 and was largely a manufacturing community. Major industries included the Eagle Valley and Ridgway tanneries of the Elk Tanning Company, the Ridgway Machine Works, and the Russell Car and Snow Plow Works.

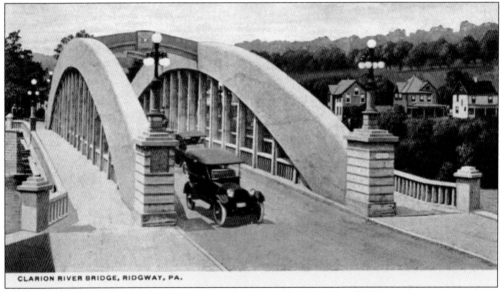

CLARION RIVER BRIDGE, RIDGWAY, PA.

Two major roads meet at Ridgway and funnel traffic onto the Bucktail Highway: State Route 948 from the west and U.S. Route 219, formerly called the Buffalo-Pittsburgh Highway, from the north and south. Travelers entering town by West Main Street once crossed the Clarion River by the landmark bridge shown on this card, postmarked 1918. Built in 1914, the Clarion River Bridge was the largest single-span reinforced concrete bridge in the United States. It was demolished in 1974 by 15 sticks of strategically placed dynamite.

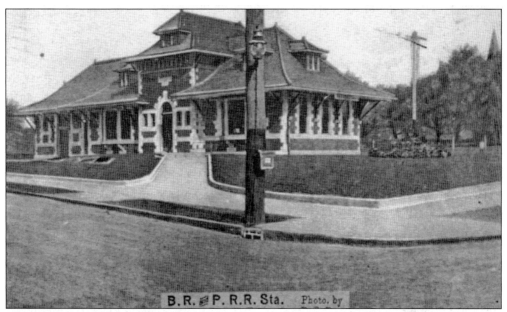

Railroad service first linked Ridgway with the rest of the region in 1864. The major rail lines were run by the Pennsylvania Railroad and the Buffalo, Rochester, and Pittsburgh Railroad (BR&P). In 1904, the BR&P ran four trains daily through Ridgway with night sleeper service between Buffalo, Rochester, and Pittsburgh on two of the trains. Passenger service was discontinued in 1955. The BR&P station, seen in this card postmarked 1911, was built in 1905 and stands today in West Ridgway.

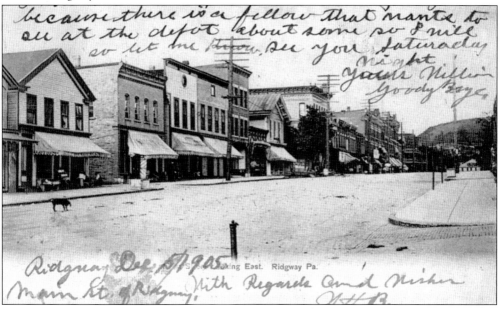

Main Street was, and is, the main hub of West Ridgway. In 1904, S. M. Weaver purchased the Elk Cigar Factory and moved it to Main Street in Ridgway. He employed six to eight cigar makers with an annual production valued at $200,000. This card, postmarked 1905, shows a view of "Main Street Looking East." The town, complete with wandering dog, looks like it is just waking up.

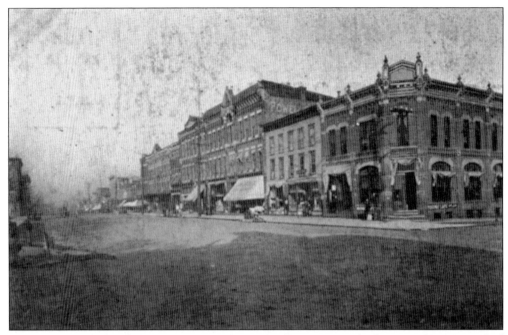

Here are two views of Main Street in Ridgway looking westward; the second is postmarked 1906. The Powell and Kime Building can be seen in the middle right of the images. Kime was considered to be "one of the best known and popular businessmen in this part of the country, a generous patron of all civic enterprises and an ardent booster of every measure that is designed to make Ridgway a larger and better civic center."

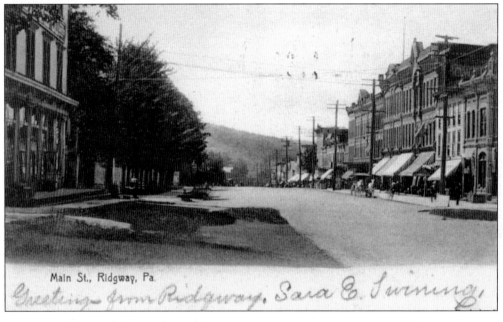

Main St., Ridgway, Pa.

Greeting from Ridgway. Sara E. Swining.

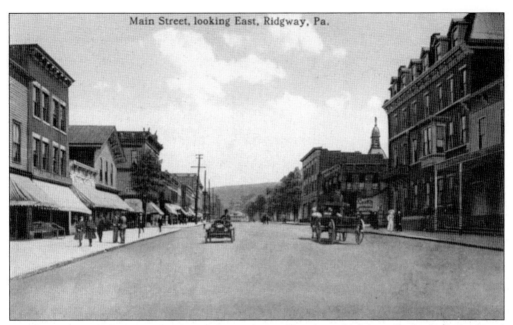

Main Street, looking East, Ridgway, Pa.

Another important business was the Smith Brothers Company, which bought the Hall, Kaul, and Hyde Company store in 1926. The Smith Brothers department store offered "women's ready to wear, dry goods and notions, dress goods, silks, millinery, toiletries, lingerie, shows, men and boys clothing and haberdashery, furniture, rugs and carpets, lace curtains, Victrolas and records, hardware, china and glassware, house furnishings, and fabrics for interior decorating."

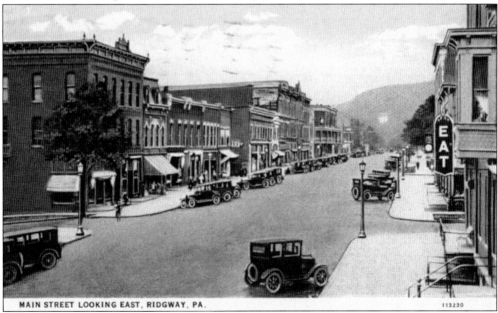

MAIN STREET LOOKING EAST, RIDGWAY, PA. 113230

This view of Main Street Ridgway looking east was postmarked in 1929. Among the major businesses in town at the time was the Hall, Kaul, and Hyde Company store. Its first floor was "devoted to fine groceries, retail bakery, green goods, butter and cheese department, and retail meat market." The second floor was a bakery that "runs day and night, employing some 14 people."

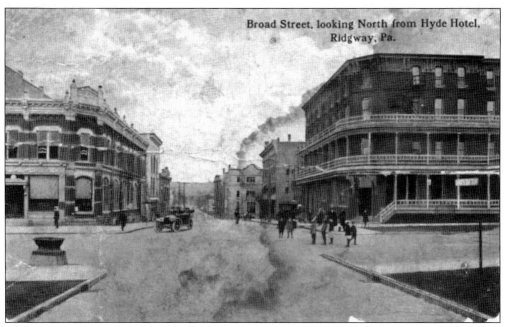

This image, postmarked 1916, is titled "Broad Street, looking North from Hyde Hotel." Broad Street is also currently the route of U.S. 219 north leaving town.

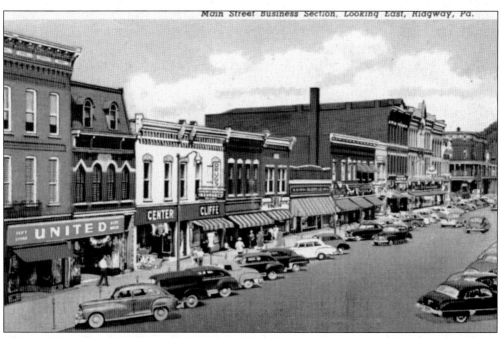

Main Street Business Section, Looking East, Ridgway, Pa.

This card shows a view of the Main Street business section of Ridgway looking east; it is dated 1939. A travel guidebook of the time notes that Ridgway's "business section is small and modern; on the whole, the community is fresh and pleasing."

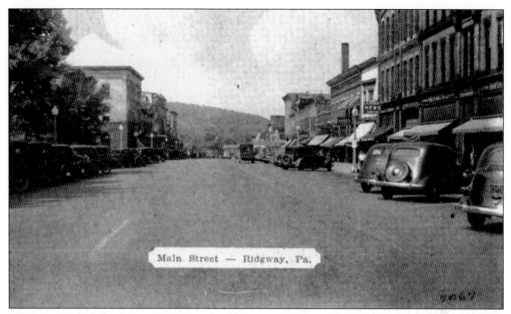

Main Street — Ridgway, Pa.

This view of Main Street Ridgway, looking west, is from the early 1950s. Then as today, diagonal parking in the downtown was the rule. Important businesses of the time included the Ridgway News Stand, the G. C. Murphy Company variety store, Cliffe's Drug Store, and the Center Market.

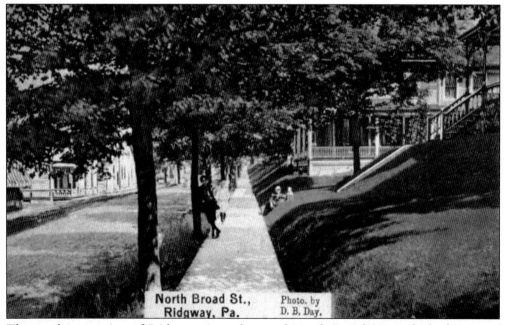

North Broad St., Ridgway, Pa. Photo. by D. B. Day.

The northern section of Ridgway, in and around North Broad Street, had of a mix of residential, industrial, and commercial buildings, including the Eagle Valley Tannery and the Hyde-Murphy plant. This card from the early 1900s shows a view of the residential section of North Broad Street.

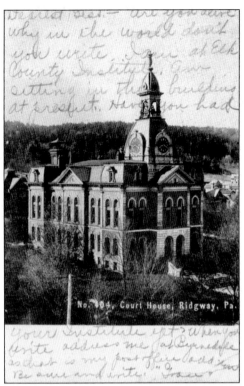

This view of the Elk County Courthouse on Main Street in Ridgway is postmarked 1906. Part of the message on the cards reads, "I am at Elk County Institute. Am sitting in this building at present. Have you had your Institute yet?" An "institute" was similar to today's teacher in-service training and lasted two weeks. Elk County's first institute was held in June 1856.

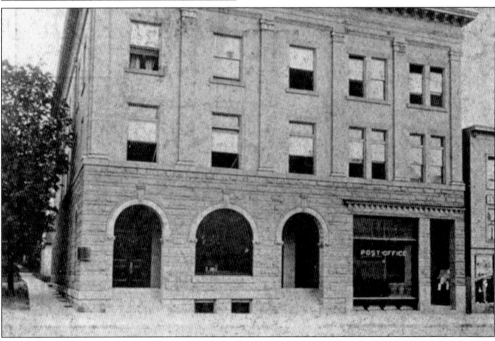

The Ridgway National Bank was established in 1901 with assets exceeding $190,000 at the end of the year. The building shown in this postcard, located on the corner of Main and Court Streets, was completed in 1903. It was built by M. V. Van Etten of Warren, who also built the Elk County Jail. By 1924, assets of the Ridgway National Bank totaled $1.7 million.

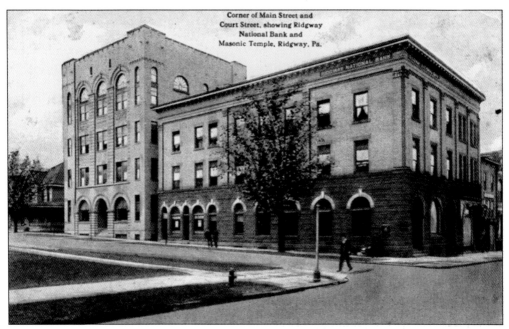

Corner of Main Street and
Court Street, showing Ridgway
National Bank and
Masonic Temple, Ridgway, Pa.

This image of the corner of Main and Court Streets shows the Ridgway National Bank to the right and the Masonic temple to the left. The Masonic temple building was completed in 1908. The large multistory building housed many local companies and organizations over the years while providing a home to the Masonic Order.

POST OFFICE, RIDGWAY, PA.

The first post office in Ridgway was thought to have been established in 1829 on West Main Street. The Ridgway post office moved into its present site on October 12, 1917. The post office once had temporary quarters on the first floor of Ridgway National Bank, as seen in the image on page 16 of this book. The post office is located on the right side of the building.

17

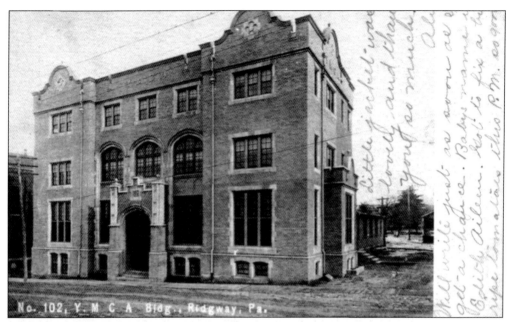

The Ridgway YMCA was established in the early 1900s to provide "organized and supervised recreation" for the town's young people. The YMCA first used temporary space for its programs on the second floor of the Ridgway National Bank and then the post office before a dedicated building was constructed. Completed in December 1905 at a cost of $30,000, the YMCA building on North Broad Street, shown in this card postmarked 1908, is still in use.

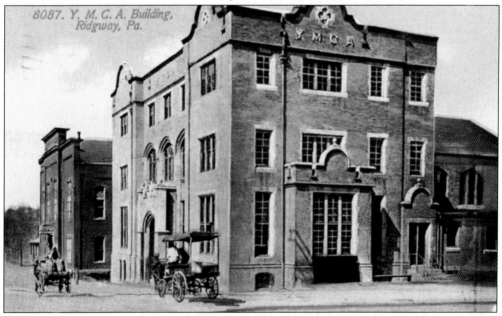

To the left of Ridgway's YMCA building in this image, postmarked 1912, is the armory, constructed in 1904 by the Hyde-Murphy Company. The armory was the headquarters of Pennsylvania's National Guard Company H through World War I and subsequently housed several other National Guard companies and units. Shortly after construction, the armory housed meeting rooms of the Elks Club, a restaurant, and a swimming pool and Turkish bath.

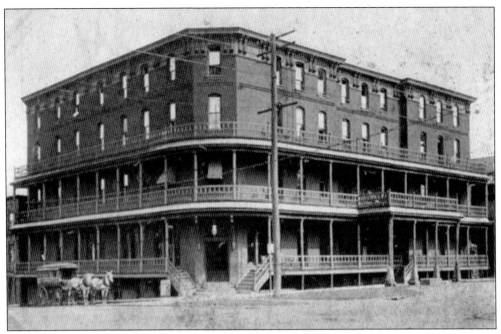

The Hyde Hotel was built in 1858–1859 by Joseph S. Hyde. The hotel went through many proprietors and renovations during its commercial life and was a favorite with travelers and local diners. It was dismantled in 1965, and a drive-through bank currently resides in its place.

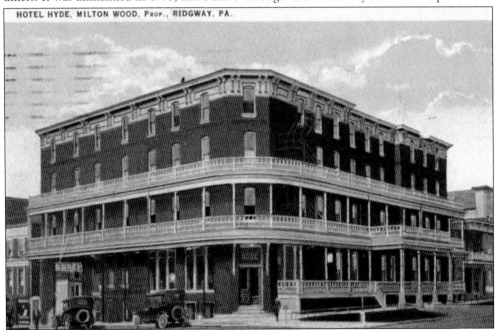

Milton Wood purchased the Hyde Hotel in 1912 and immediately began to dramatically improve the property, seen in this card postmarked 1923. A promotional advertisement from 1924 noted that Wood was "installing a modern elevator, changing stairs, installing new water and heating systems, telephone in every room, and doubling the size of the ladies waiting room . . . When completed this hotel will be second to none outside of the largest cities."

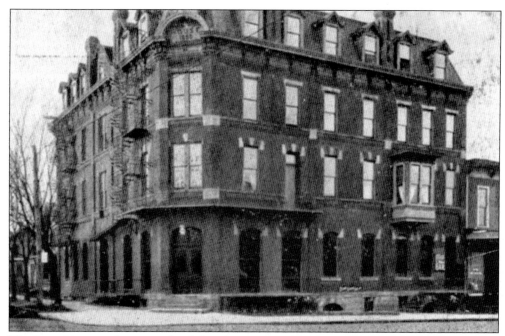

The Ross House, a four-story brick hotel, once stood at the corner of Main and Mill Streets. Established in 1883 by James Schwartz and Edward Ross, the building was bought by Charles Salberg in 1905 and became the Salberg Hotel. The Salberg Hotel had a public bath and restroom widely used by Ridgway visitors and locals. It also sported the first electric lights in the town.

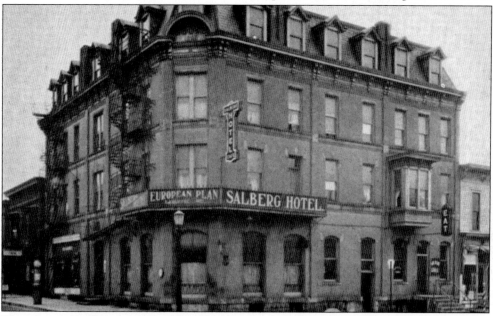

Theodore J. Duffee, a native of Bradford, began managing the Salberg Hotel in 1918 and purchased it outright in 1924. An advertisement from 1924 notes, "Mr. Duffee has a reputation all through northwestern Pennsylvania as a caterer—equal to any emergency. He conducts one of the best hotels in this part and enjoys a very liberal patronage." Duffee later sold the hotel to Lawrence Salberg, son of Charles. After many owners it was demolished in 1966.

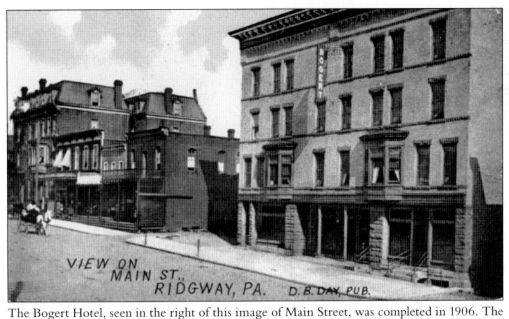

The Bogert Hotel, seen in the right of this image of Main Street, was completed in 1906. The Bogert Hotel boasted the first elevator in Elk County and had "seventy-six sleeping rooms, each floor with a lavatory and bathroom." An 1845 section of the Elk County Courthouse formed part of the hotel's back side and a portion of its dining room. The Salberg Hotel is seen at the extreme left of the image.

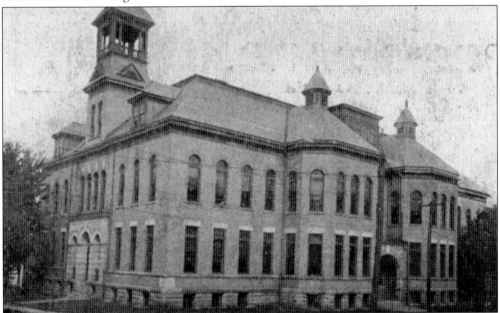

Education was an important concern in Ridgway since the first subscription school met in the log house of James Gallagher in 1826. By the 1890s, increasing enrollments led Ridgway to construct a new 16-room school, designed by the architect H. C. Park and built by Hyde-Murphy Company. Critics of the Central School, shown in this card, predicted a long lag in populating the school, but this happened quickly, causing the town to rent rooms in a nearby church to meet space needs.

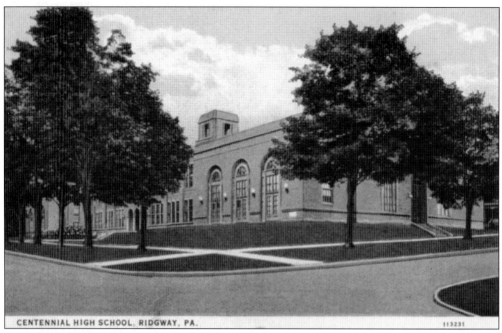

CENTENNIAL HIGH SCHOOL, RIDGWAY, PA.

113231

Growth of the Ridgway area schools continued through the 1920s when the system consisted of 41 teachers and 1,200 students. Centennial High School, seen in this card postmarked 1928, was built by the Hyde-Murphy Company on Center Street in Ridgway and dedicated on July 4, 1924. The message on the card's back reads, "How are you spending your vacation? Do you swim? It is about all they do here." This building currently houses Elk County offices.

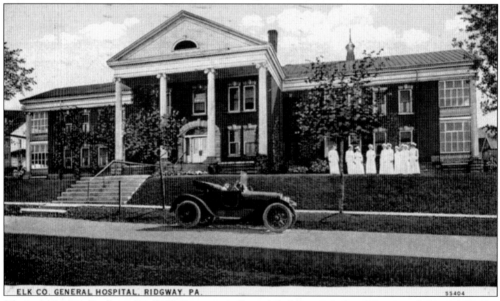

ELK CO. GENERAL HOSPITAL, RIDGWAY, PA.

55404

To meet the medical needs of Elk County, influential citizens such as Harry and George Hyde, Elizabeth Hyde, and J. P. K. Hall, among others, donated land and contributed money for a county hospital to be located in Ridgway. Ridgway architect H. C. Park designed the building. The Elk County General Hospital, shown in this card postmarked 1929, was officially opened to the public on November 19, 1902, and admitted its first patient three days later.

Lumbering was the first major industry in Elk County. Sawmills began operating in the area in the early 1820s, and by 1826, Enos Gillis had opened Ridgway's first sawmill. Early lumbering focused on valuable white pine that could be rafted down area streams and rivers in early spring and fall. This image, made by Wiese Studio of Ridgway, shows two young men with log cants or peaveys standing on a pile of hardwood logs.

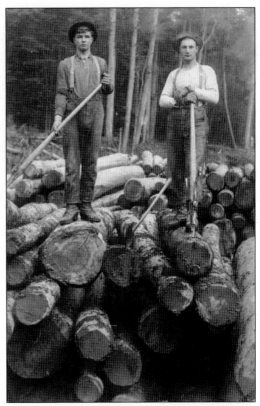

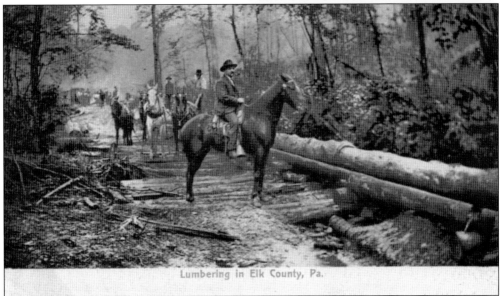

Lumbering in Elk County, Pa.

Before the development of logging railroads, horses provided the heavy power needed to move logs across the forest. This card, captioned "Lumbering in Elk County, Pa.," shows men and horses at a logging job. The log, or corduroy, road on which the horses are standing provided traction and stability on rutted forest soils. The log slide seen on the right of the image was a wooden chute used to move logs down steep valley slopes.

23

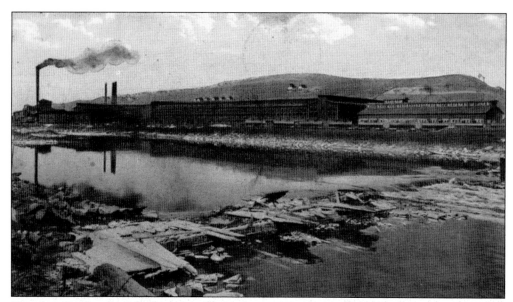

The abundant hemlock forests of the region became a valuable resource as the leather-tanning industry grew in northern Pennsylvania. Hemlock bark contained the tannins needed to tan or treat and soften leather. The Eagle Valley Tannery, seen in this card postmarked 1918, was established along the Clarion River in Ridgway during the early 1870s and eventually became one of the largest tanneries in the country. By 1928, it processed 1,000 hides daily with an annual consumption of 20,000 cords of hemlock bark.

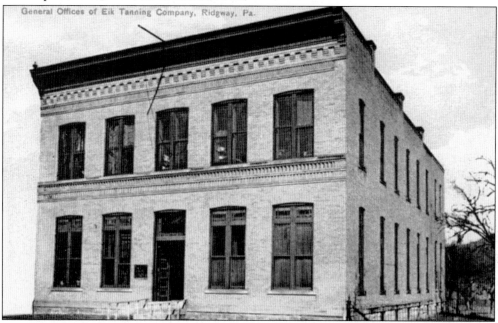

The Elk Tanning Company bought the Eagle Valley Tannery in 1893. Ridgway became the corporate headquarters for the company, which operated numerous tanneries throughout the region. The Elk Tanning Company became a subsidiary of the United States Leather Company, which liquidated its assets in the early 1950s. This card shows the general offices of the Elk Tanning Company in Ridgway in what would later become the Knights of Columbus building.

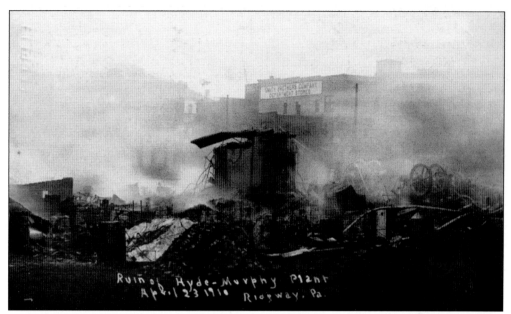

Ruin of Hyde-Murphy Plant
Apr. 23 1910 Ridgway, Pa.

The Hyde-Murphy Company, incorporated in Ridgway in 1901, was one of the largest woodworking mills in the United States. It manufactured "hardwood interior finish, trim, bank and office fixtures, hardwood mantles, stair building, panel work and grill work" and worked on notable public buildings such as the Pentagon and the Smithsonian Institution. This card shows the aftermath of the disastrous Hyde-Murphy fire of 1910. The plant was rebuilt in a year and operated until 1961.

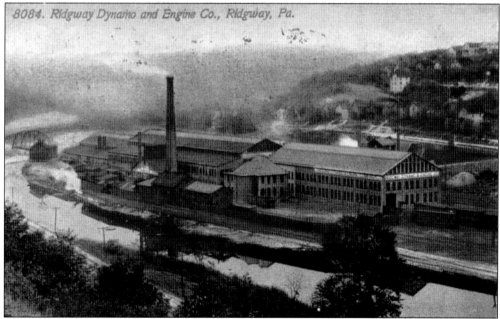

8084. Ridgway Dynamo and Engine Co., Ridgway, Pa.

The Ridgway Dynamo and Engine Company specialized in manufacturing crank steam engines and direct current generators. The company was highly profitable from 1897 to the early 1920s, but little profit was put back into the business, causing financial distress. The company's plant on the Clarion River, shown here on a card postmarked 1912, was built in 1892 by J. H. McEwen.

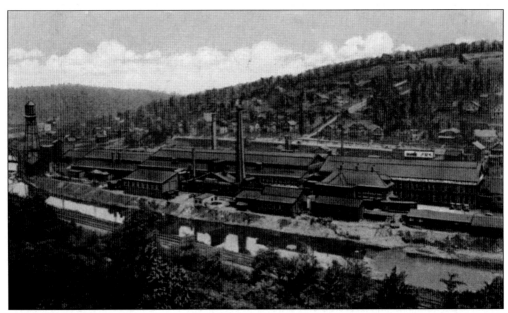

In 1927, the Ridgway Dynamo and Engine Company was acquired by the Elliott Company and became its Ridgway division. During World War II, the Ridgway division manufactured electrical machinery and United States Navy submarines propellers and employed more than 1,200 workers. The Carrier Corporation, refrigeration manufacturers, purchased the Elliott Company in 1958 but folded the Ridgway division in 1962. The Weyerhaeuser and Louisiana Pacific companies operated on the site through the 1970s, but by 1980, the plant was idle.

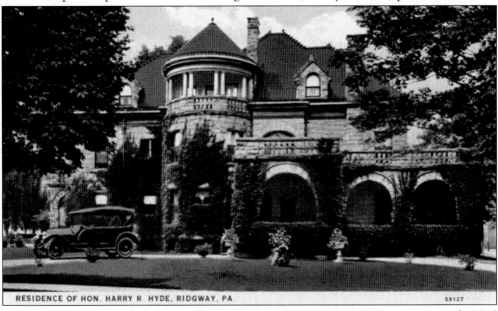

RESIDENCE OF HON. HARRY R. HYDE, RIDGWAY, PA. 59127

Ridgway, called the "Lily of the Valley," is known for its many historic mansions of varied architectural styles largely built by fortunes made in lumber and manufacturing. Ridgway was said to have once been home to 17 millionaires, the most in Pennsylvania. This card shows an image of what is now called the Mrs. William H. Hyde Residence, a Romanesque mansion located on Main Street. This home was built in 1907, a few years after William H. Hyde's death.

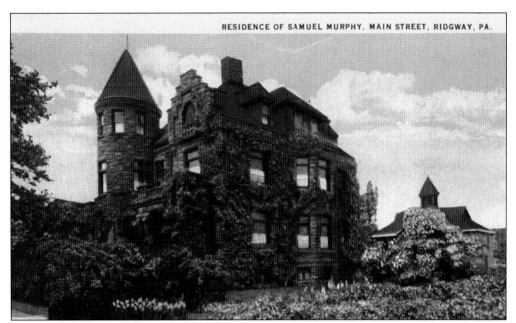

Walter P. Murphy, a lumber manufacturer, entered into a partnership in 1884 with Joseph S. Hyde and William H. Hyde that would evolve into the Hyde-Murphy Company. The two families were close and built mansions across the street from each other. This card depicts the "Residence of Samuel Murphy, Main Street, Ridgway, Pa." Samuel assumed leadership of the Hyde-Murphy Company in 1920 on this father's death. The mansion was destroyed by fire in 1956.

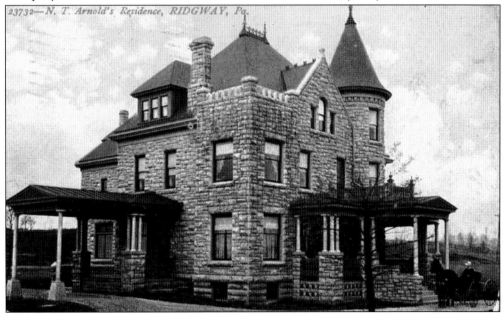

Bonifels, known as the N. T. Arnold residence, was built in 1897. Arnold was born in Allegany County, New York, in 1857. An attorney at law, he and his wife, Hannah, were considered among the most "prominent young people of Ridgway" in 1890. Arnold had "great interest in his professional practice" and was also "devoted to scientific studies, taking an especial interest in the study of astronomy."

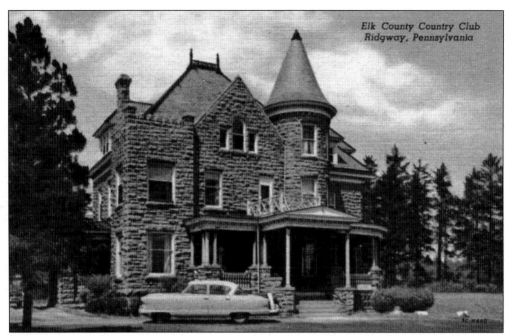

Elk County Country Club
Ridgway, Pennsylvania

Bonifels was constructed of Vermont gray granite, an uncommon building material for the region, and its commanding location on Laurel Mill Hill, overlooking Ridgway, was likely chosen in part by N. T. Arnold's passion for astronomy. Bonifels was the clubhouse for the Elk County Country Club, chartered in 1923. In 1971, a new $260,000 clubhouse was built, and Bonifels was retired from service.

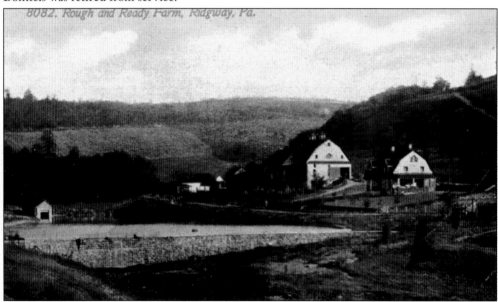

8082. Rough and Ready Farm, Ridgway, Pa.

The property that encompassed Rough and Ready Farm in the southern section of Ridgway near Gallagher Run belonged to the Hyde and Hall families, united by the marriage of J. P. K. Hall with Kate M. Hyde. The name Rough and Ready was given to the property on both sides of Gallagher Run when Ridgway was first laid out in the early 1820s, probably in reference to the condition of the land for settlement.

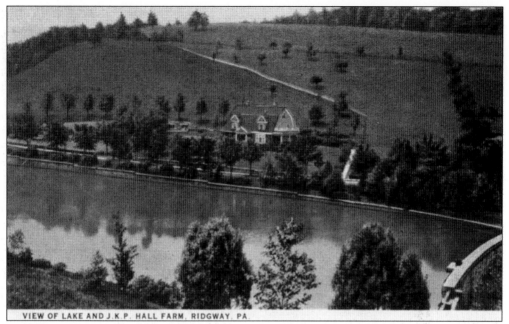

VIEW OF LAKE AND J.K.P. HALL FARM, RIDGWAY, PA.

This card, postmarked 1927, is captioned "View of Lake and J.K.P. Hall Farm." J. K. P. Hall was trained as a lawyer but turned his interests to business involving lumber, coal, manufacturing, real estate, and railroads. He was a U.S. congressman and state senator and, along with his wife, Kate, was a philanthropist for Ridgway and Elk County concerns. After Hall's death in 1915, Kate moved to Rough and Ready Farm. She died in 1937.

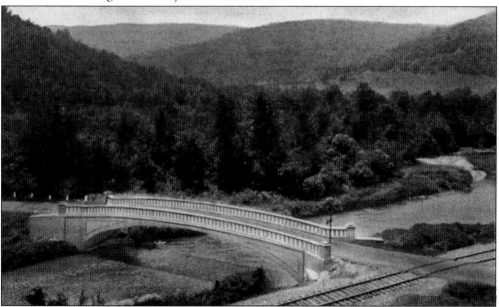

This card, dated 1939, shows a view of a bridge crossing Elk Creek on the Bucktail Highway. Single-span bridges on the Bucktail Highway at this time were constructed of concrete and were simple yet pleasing to the eye. Elk Creek may not have been so pleasing, however, as it received waste from many of the industries upstream. In the early 1900s, the waters of Elk Creek were said to be "inky black" due to tannery and mine wastes.

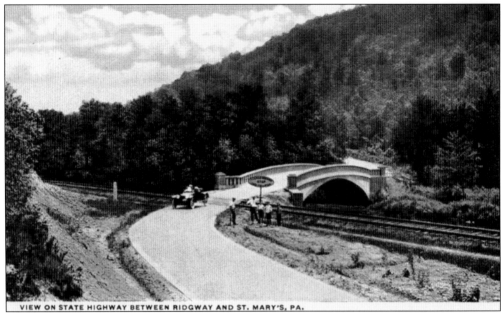

VIEW ON STATE HIGHWAY BETWEEN RIDGWAY AND ST. MARY'S, PA.

This card shows a bridge and railroad crossing on the Bucktail Highway between Ridgway and St. Marys. The oblong sign next to the railroad was a caution sign for highway travelers that read, "Railroad Crossing—Stop, Look, Listen." A 1940s travel guide notes that east of Ridgway "US 120 winds along Elk Creek between high rounded bluffs, some heavily wooded, some covered with scrub growth, and some bare."

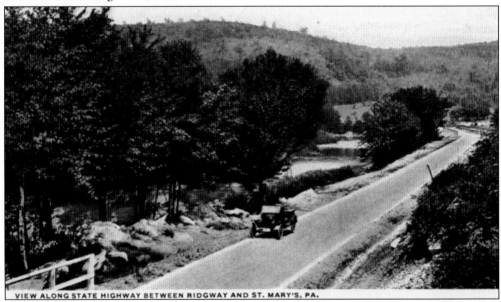

VIEW ALONG STATE HIGHWAY BETWEEN RIDGWAY AND ST. MARY'S, PA.

This card, dated 1916, shows a view of a car "along state highway between Ridgway and St. Mary's." Between Ridgway and St. Marys the Bucktail Highway crosses only one other locale, the village of Daguscahonda. The origin of the village's name is uncertain but may mean "wildcat" in a Native American language. Daguscahonda was initially supported by the lumber industry. Later it had a hemlock bark extract plant that supplied local tanneries and a sand plant using local sandstone.

Two

St. Marys

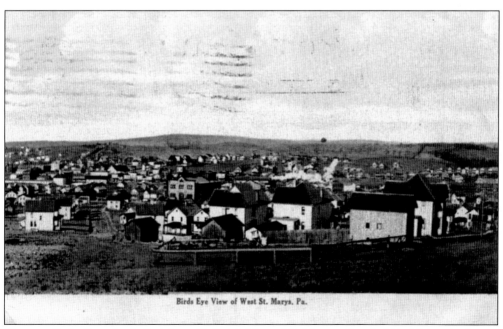

Birds Eye View of West St. Marys, Pa.

German Catholics who hailed from Philadelphia and Baltimore founded St. Marys, or Sancta Marienstadt, in 1842. They left behind the religious intolerance they felt was growing in these eastern cities. Their goal was to found an agrarian community in western Pennsylvania based on equality and religious freedom. This card, postmarked 1911, shows a "birds eye view of West St. Marys."

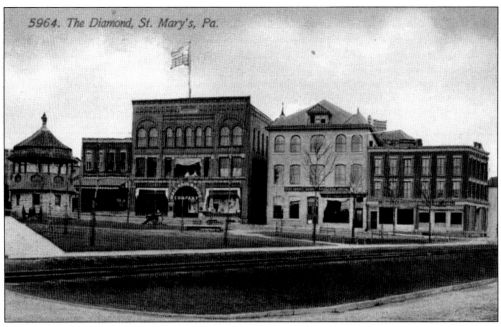

5964. The Diamond, St. Mary's, Pa.

This postcard of the diamond, published by L. Wright Variety Store, shows the main commercial center of St. Marys with its shops and businesses, central green, and bandstand. The flag-bearing building in the middle of the image is the Hall, Kaul, and Hyde Company store. The St. Marys National Bank and the Hall and Kaul Lumber Company office, respectively, appear at the store's right.

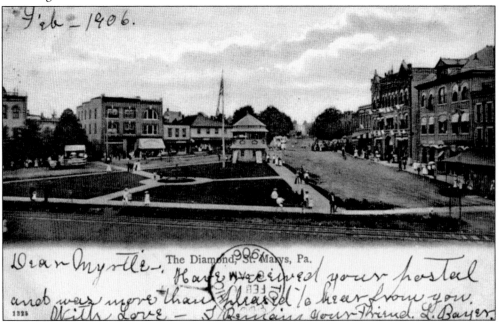

Here is another view of the diamond, this from a card postmarked 1906. At the center of the image is the bandstand, which also functioned as the town's gas regulator. The circular walkway below and to the left of the bandstand surrounded an iron water fountain. The Pennsylvania Railroad line passes the diamond at the bottom of the image.

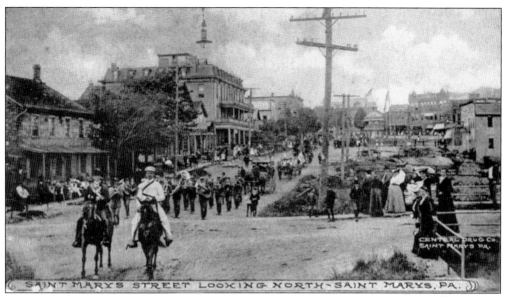

This card, published by the Albertype Company of Brooklyn, New York, shows a view of "Saint Marys Street Looking North" toward the diamond, as a parade marches through town. The building in the left of the image, built in 1845 by George Weis, was the first stone building erected in the town. Today it houses the philanthropic Stackpole-Hall Foundation. The large building at left center is the Franklin Hotel.

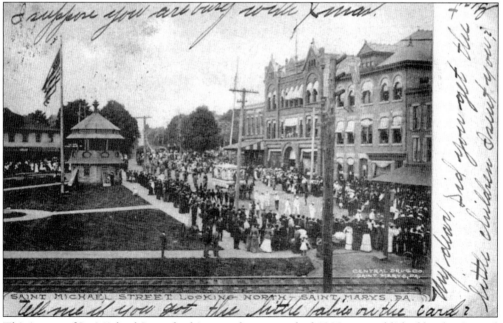

This image of St. Michael Street looking north, postmarked 1905, was published by the Central Drug Company of St. Marys and shows another parade moving past the diamond. The building to the right of the image is the St. Marys National Bank. The Hall and Kaul department store appears to the left of the bank.

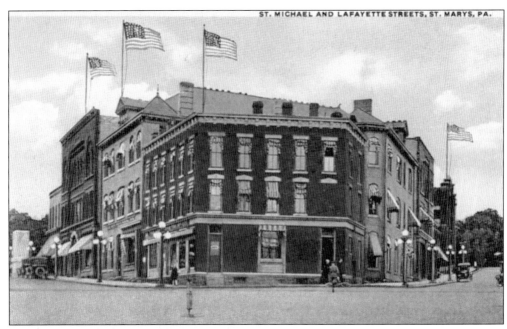

This card show the corner of St. Michael and Lafayette Streets, often called the Trust Company Corner. The Wilhelm Building at the corner housed the St. Marys Trust Company, organized in 1903. The Wilhelm Building was replaced with new facilities in 1970. The St. Marys National Bank, located behind the Wilhelm Building in this image, eventually merged with the successor to the St. Marys Trust Company, the Elk County Bank and Trust Company.

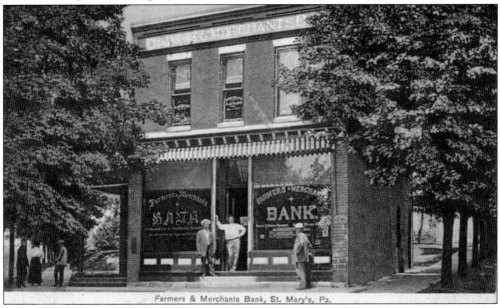

Farmers & Merchants Bank, St. Mary's, Pa.

The Farmers and Merchants Bank, shown in this card postmarked 1910, was located on the corner of North Michael and North St. Marys Streets. The bank was organized in 1910 and became the Deposit Bank after a merger in 1977. The brick building, remodeled in 1953 and 1956, was constructed after the fire of 1880, which consumed over 50 buildings along North St. Marys Street and Erie Avenue.

The Hall and Kaul Company store, located on the eastern portion of the diamond, is shown on this card postmarked 1911. A portion of the Coryell and Russ Company store can be seen on the left. The cornices at the top of the Hall and Kaul building were eventually removed. The building later housed the Smith Brothers department store.

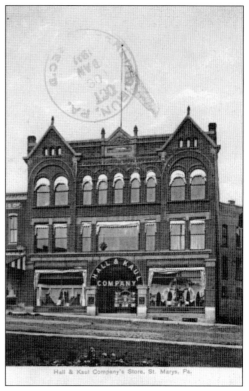

Hall & Kaul Company's Store, St. Marys, Pa.

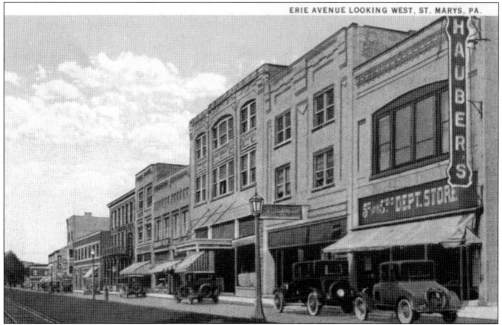

ERIE AVENUE LOOKING WEST, ST. MARYS, PA.

Erie Avenue was an important commercial section of St. Marys with its numerous stores, hotels, and the Family Theatre. The Pennsylvania Railroad passenger station was also located on Erie Avenue. This view of "Erie Avenue Looking West" shows Hauber's "5¢ to $5.00 Dept. Store" on the right.

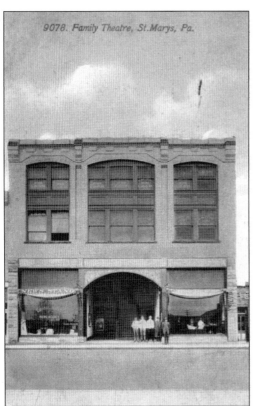

9078. Family Theatre, St. Marys, Pa.

This card, postmarked 1910, shows an early image of the Family Theatre. There were several theaters in St. Marys, including the Temple Theatre on Brussells Street, which opened in 1902. Touring companies from large cities as well as local talent performed at the town's theaters.

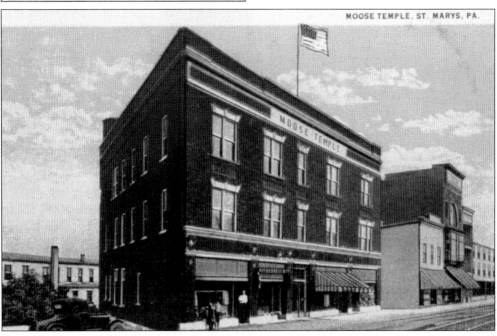

MOOSE TEMPLE, ST. MARYS, PA.

This is a view of the first Moose temple in St. Marys, on a card postmarked 1928. It was located on Erie Avenue near the Pennsylvania Railroad station. In 1922, it was gutted by a fire that started in an adjacent building.

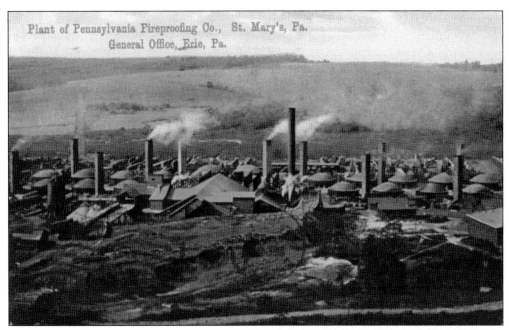

The Pennsylvania Fireproofing Company was founded in 1901, and its St. Marys plant is shown in this card postmarked 1912. It was one of four companies that exploited the rich clay deposits around St. Marys. Fireproof clay products such as building blocks and terra-cotta floor arches were baked in the numerous beehive kilns seen in this image. Clay used in production was mined from the open bank seen in the front left of this image.

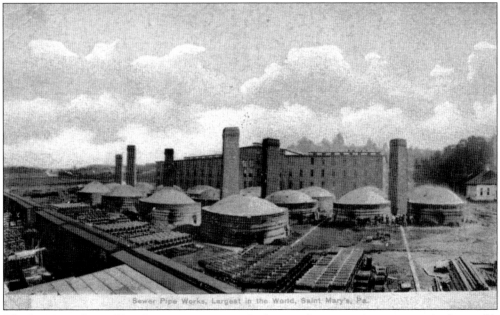

The St. Marys Sewer Pipe Company was once the largest clay sewer pipe company in the world. Andrew Kaul and J. K. P. Hall organized the company in 1901, and its first sewer pipe emerged from the kilns on February 25, 1902. The plant was located off Theresia Street. Note the quantity of stacked sewer pipes awaiting transport in the front of the image.

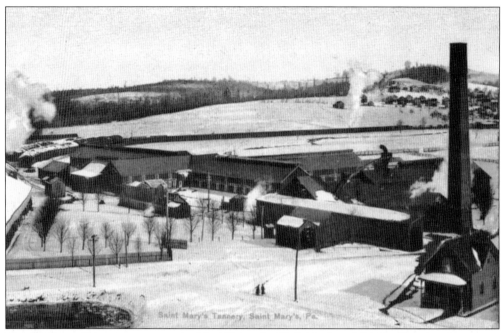

The St. Marys Tannery was organized in 1884 as the Hall, Kaul, and Kistler Tanning Company. It operated until 1955. In the early 1900s, the tannery had a capacity of about 320 green hides daily. The size of the plant can be gauged by the two people standing in the lower center of the image.

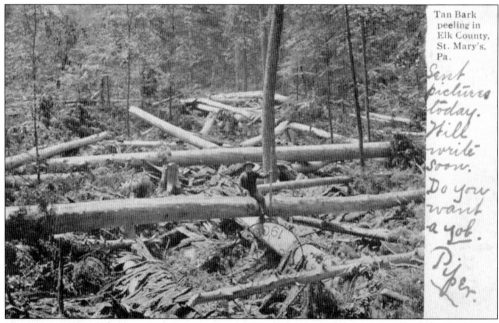

Abundant hemlock trees of the region supplied the necessary ingredient for tanning leather: tannin-rich bark. Bark peeling was done in the spring and early summer when hemlock bark was loose and easily stripped from trees. This card, postmarked 1906, shows bark peeling in action near St. Marys. The message on the front of the card asks the recipient, "Do you want a job?'

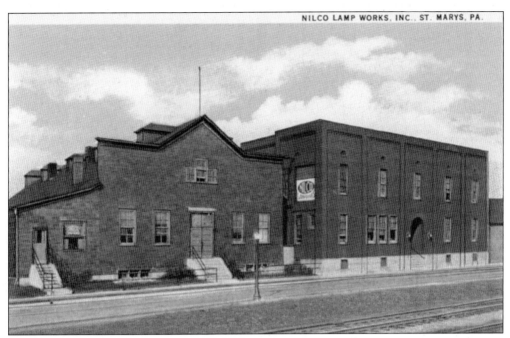

Locally known as the NILCO Lamp Works, the Novelty Incandescent Lamp Company was located on Erie Avenue. NILCO was founded in St. Marys in 1905 and manufactured decorative and specialty lamps, particularly for the medical and emerging automotive industry. NILCO developed into the Sylvania Company, manufacturing radio tubes. Sylvania moved into larger facilities in St. Marys in 1955 and donated the former NILCO buildings to the town.

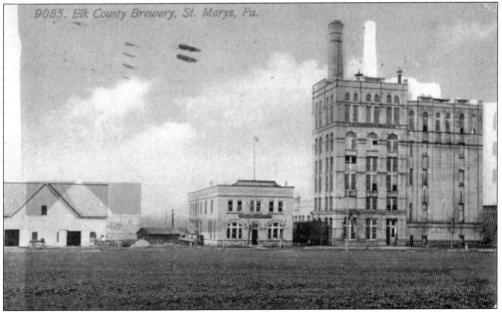

9085. Elk County Brewery, St. Marys, Pa.

This card, postmarked 1913, shows a view of the Elk County Brewery of the St. Marys Brewing Company, formerly located on Hall Avenue. The brewery was later converted into a carbon plant by the Pure Carbon Company. The message on the card's back reads, "This is where I spend all of my time. How would you like to be with me?"

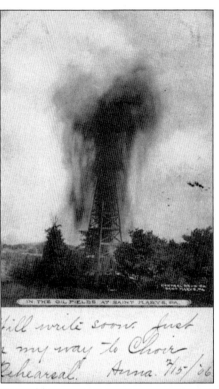

This card postmarked 1906 and titled "In the Oil Fields of Saint Marys, Pa." shows a gushing oil well. Although St. Marys is close to major oil fields, it is not known for oil production. In contrast, coal was mined extensively in and around St. Marys, including the Hazel Dell Mine, a shaft mine located near Brussells Street.

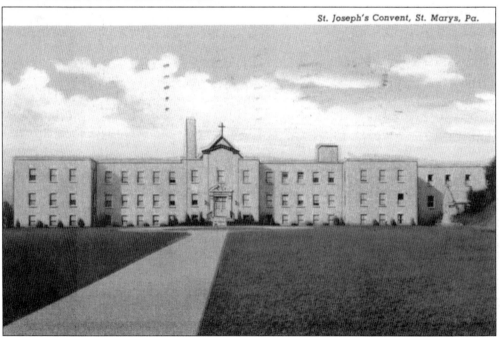

St. Joseph's Convent, St. Marys, Pa.

Priests and monks of the Benedictine Order first came to St. Marys in 1850. St. Joseph's Convent, founded in 1852 and shown in this card postmarked 1947, is the oldest Benedictine women's community in the United States. The convent serves as the Motherhood for the Benedictine Order in the United States.

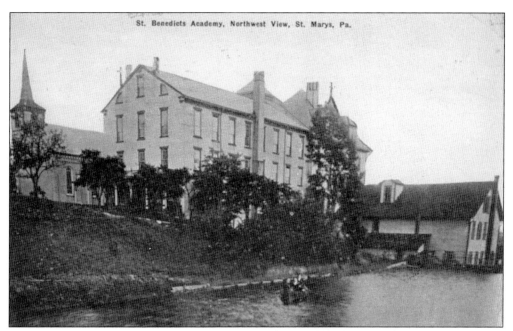

St. Benedicts Academy, Northwest View, St. Marys, Pa.

The Benedictine school at St. Marys, shown in this card postmarked 1912, was part of a larger complex that included St. Marys Church, the convent, and the school. St. Benedict's Academy was a private girls' school taught by nuns. Lake Benita is located next to the school. The lower image, postmarked 1905, shows a bird's-eye view of the school's formal gardens.

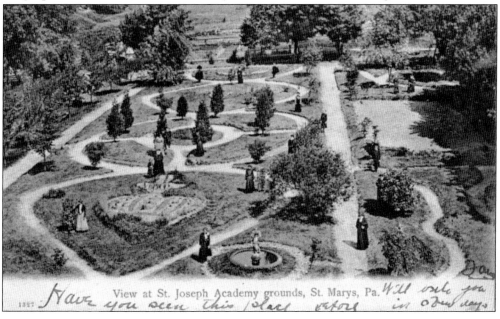

View at St. Joseph Academy grounds, St. Marys, Pa.

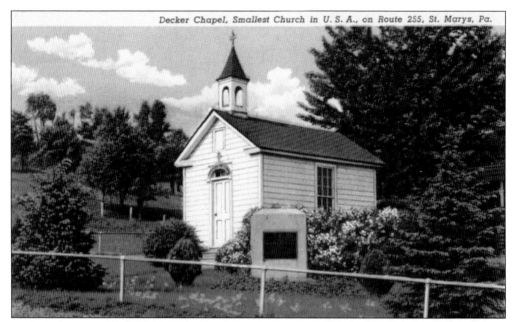

Decker Chapel, south of the Bucktail Highway on Route 255, is said to be the smallest church in the United States. It is always open. The chapel was built by Michael Decker in 1856. Decker fell from an apple tree while pruning it and sustained a major back injury from the fall. He swore to build a church if he recovered. Recover he did, and his chapel stands today. Decker Chapel is listed on the National Register of Historic Places.

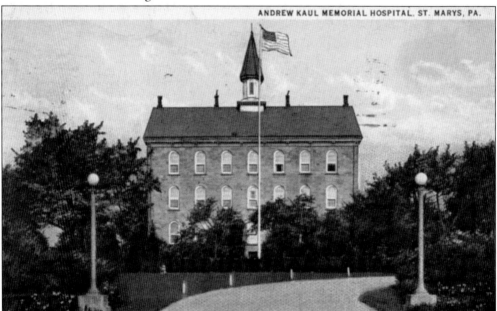

The Andrew Kaul Memorial Hospital, seen in this card postmarked 1928, was incorporated in 1920. Built in 1870 as a monastery building, it was slated to be a college. It later housed a local Benedictine priest. Andrew Kaul's three daughters purchased the building and dedicated it to their father. The hospital burned in 1935 and was rebuilt immediately. Several wings have been added through the years.

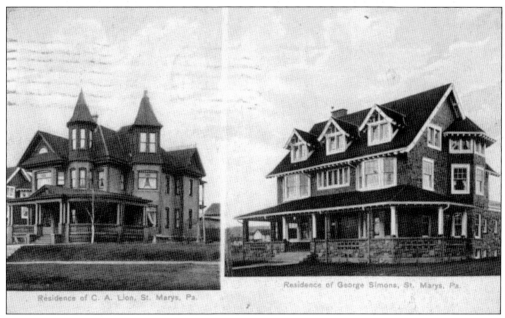

Residence of C. A. Lion, St. Marys, Pa.

Residence of George Simons, St. Marys, Pa.

This card, postmarked 1911, shows the magnificent houses of C. A. Lion (left) and George C. Simons (right) on Center Street. Lion was the proprietor of a successful meat market in St. Marys, starting his business in 1878. His parents were among first German settlers of the town. Simons was a successful industrialist.

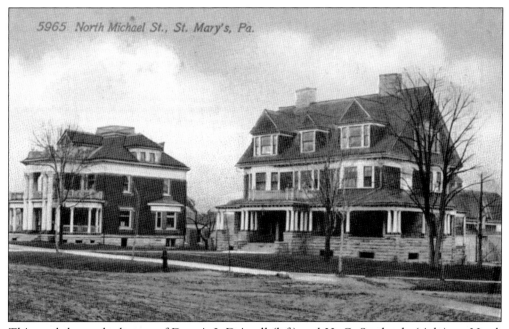

5965 North Michael St., St. Mary's, Pa.

This card shows the homes of Dennis J. Driscoll (left) and H. C. Stackpole (right) on North Michael Street. Driscoll was a teacher, lawyer, and congressman who moved to St. Marys in 1890. In 1906, Stackpole and J. K. P. Hall founded the Stackpole Battery Company, which became Stackpole Carbon in 1912, the firm that launched St. Marys's preeminence in the carbon industry.

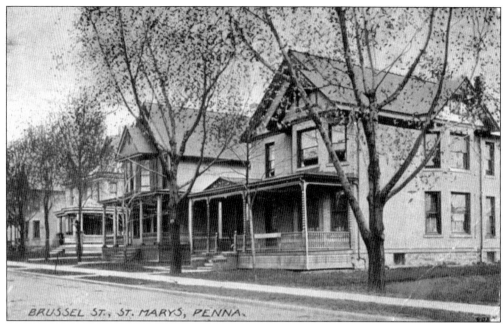

Seen here is a view of residences on Brussel Street, in a card postmarked 1913. The street's name is actually Brussells Street. Many workers and their families lived on Brussells Street, which was located close to many of St. Marys's industrial plants, such as the St. Marys Clay Products Company.

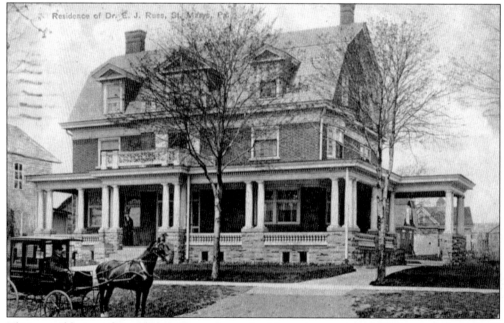

The second home of Dr. Eben J. Russ, shown in this card postmarked 1908, was built in 1913 on Center Street. Russ worked for the St. Marys Coal Company and was benevolent toward the community, donating his first home to house the St. Marys public library. He also played a vital role in organizing local medical response to the influenza epidemic of 1918.

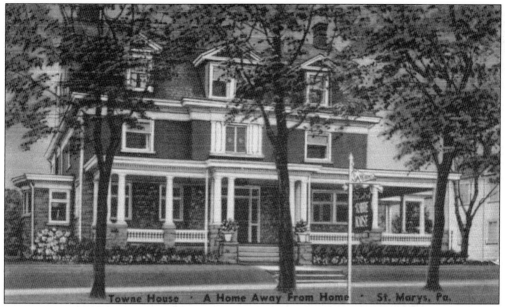

Towne House · A Home Away From Home · St. Marys, Pa.

Like some of the other mansions in St. Marys and Elk County, Russ's second home became a hotel, the Towne House, catering to tourists and business travelers. The caption on the back of this card, postmarked 1954, reads, "A new and modern hotel, furnishing comfortable accommodations to the Traveler and Tourist. Room with or without Bath, Steam Heat, Quiet and Cool. ½ Block from center of City, Theatrical and Shopping District."

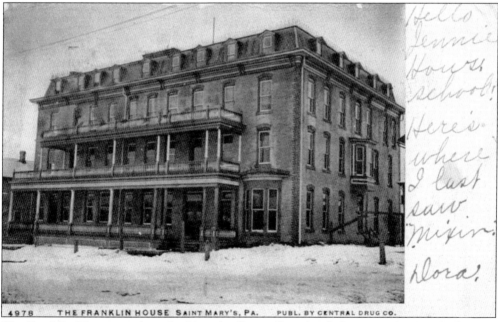

4978 THE FRANKLIN HOUSE SAINT MARY'S, PA. PUBL. BY CENTRAL DRUG CO.

The Franklin House stood overlooking the diamond on South St. Marys Street. The bar was rumored to have a full-size glass boot that could "test the capacity of beer drinkers." In 1922, fire consumed the hotel's fourth floor. The last part of the message on this card, postmarked 1906, reads, "Here's where I last saw mixin." Whether "mixin" is a person or the act of mixing a drink can only be imagined.

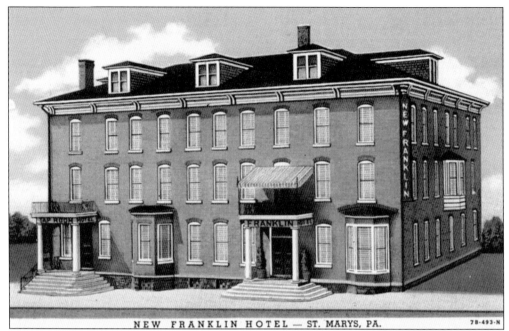

NEW FRANKLIN HOTEL — ST. MARYS, PA. 7B-493-N

After fire destroyed the fourth floor, the Franklin House was renovated and became the New Franklin Hotel, shown on this card. Besides the fourth floor, the former verandas are gone, replaced with pillared entryways. The sign on the left entrance reads, "Tap Room." The New Franklin Hotel was completely destroyed by fire in 2000.

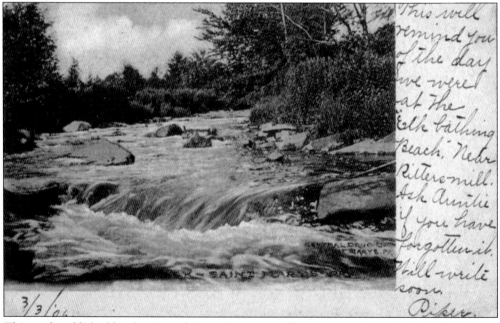

This card, published by the Central Drug Company of St. Marys and postmarked 1906, shows an image of a rushing stream near St. Marys. The message written on the front of the card reads, "This will remind you of the day we were at the Elk bathing Beach near Ritters mill. Ask Auntie if you have forgotten it."

Three

EMPORIUM

MOUNTAIN SCENERY ON BUCKTAIL TRAIL (U. S. 120) BETWEEN ST. MARYS AND EMPORIUM, PA. 1A1997

The Bucktail Highway crosses the eastern continental divide and enters the Susquehanna Valley just east of St. Marys. The valley along this section of the road is broad and more friendly to agriculture than the deep, constrained valley to the east. The message on the back of this card, postmarked 1938, reads, "This is a picture of our farm that burnt the 4th of July. We are leaving for California Thursday."

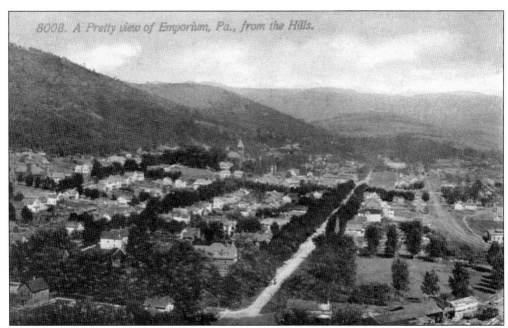

8008. A Pretty view of Emporium, Pa., from the Hills.

Emporium, the seat of Cameron County, was incorporated in 1864. The town is located on the banks of the Driftwood Branch of Sinnemahoning Creek. Sinnemahoning is a corruption of the Native American name Achsini-mahoni, which means "stony lick," denoting a rocky place where game animals come to lick salts from stream banks. The card above, postmarked 1914, shows "a pretty view of Emporium, Pa., from the hills." The card below shows a view of Emporium with a single-span bridge crossing Sinnemahoning Creek.

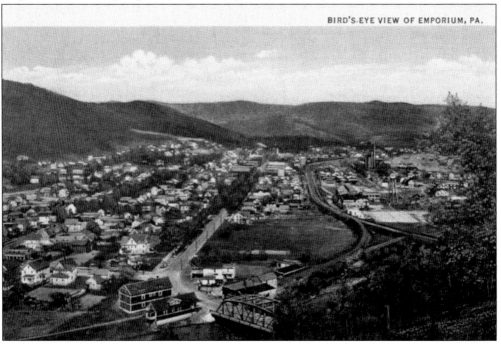

BIRD'S-EYE VIEW OF EMPORIUM, PA.

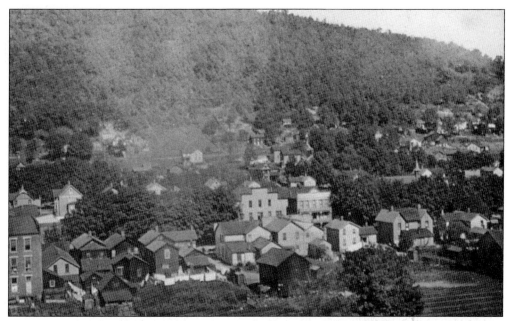

Here are two bird's-eye views of Emporium. In the card below, the prominent building at the top right of the image is the Cameron County Courthouse. Lumber spurred the early growth of Emporium, but by the 1940s, manufacturing was largely the economic base. Sylvania's radio tube plant was the largest employer for many years.

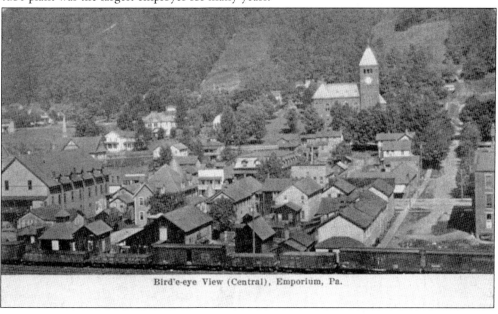

Bird'e-eye View (Central), Emporium, Pa.

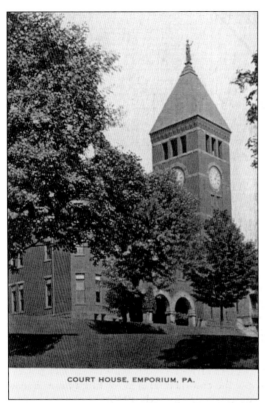

COURT HOUSE, EMPORIUM, PA.

The Cameron County Courthouse in Emporium was built in 1890 and was designed by architect A. S. Wagner. The cost estimate for the courthouse came in over budget, and as a cost-saving measure, the county commissioners deleted the clocks on the tower, having the holes bricked-in. It was not until 1900 that the clocks were added after $600 was raised by the ladies chamber of commerce.

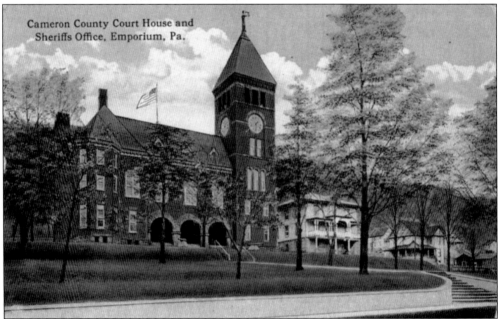

Cameron County Court House and Sheriffs Office, Emporium, Pa.

This card, postmarked 1920, shows the Cameron County Courthouse and sheriff's house, which also hosted the jail. The sheriff's house was built in 1867. The lower floor of the house was made of stone and housed the jail. The upper floors were made of wood and served as the residence for the sheriff and his family.

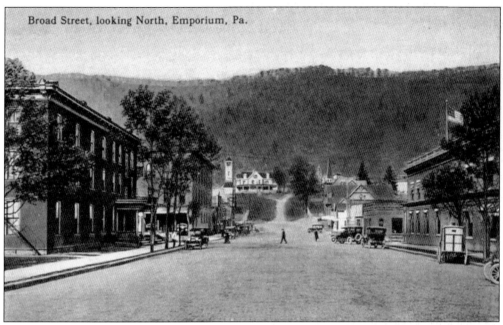

Broad Street, looking North, Emporium, Pa.

Abundant natural resources were important to the growth of Emporium, but the link to the outside world created by railroads caused the town to grow rapidly. The Philadelphia and Erie Railroad was completed to Emporium in 1863, and by 1872, the Buffalo, New York, and Philadelphia Railroad reached the town. These two cards show the commercial areas of Emporium, Broad Street looking north and East Fourth Street, respectively, in the early 1900s.

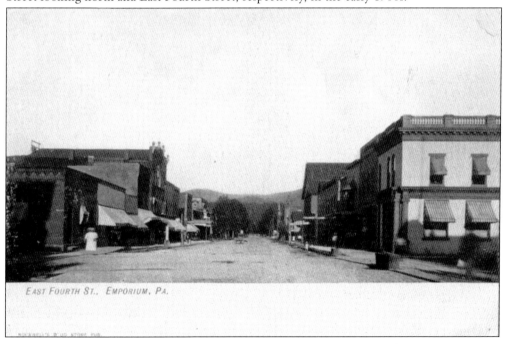

EAST FOURTH ST., EMPORIUM, PA.

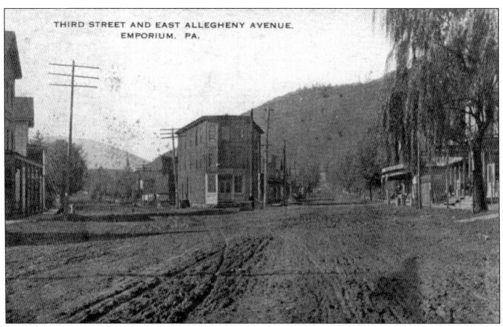

THIRD STREET AND EAST ALLEGHENY AVENUE.
EMPORIUM. PA.

A 1940s travel guide noted that Emporium was "ringed by mountains, has pleasing houses, mostly frame, and steeply graded, tree-lined streets." Aspects of this favorable description can be seen in these two cards of Third Street and East Allegheny Avenue, and West Sixth Street, dated 1912.

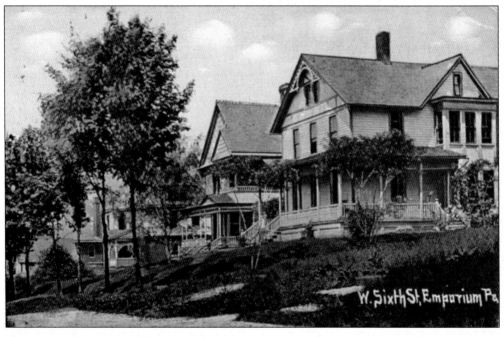

W. Sixth St. Emporium Pa.

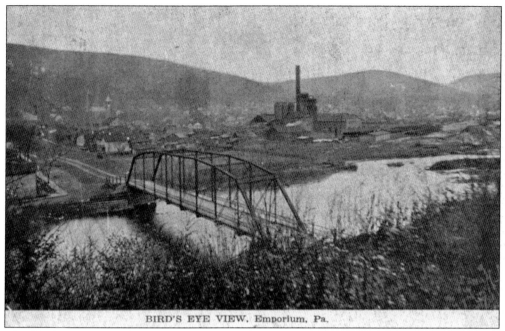

BIRD'S EYE VIEW, Emporium, Pa.

This bird's-eye view of Emporium shows its busy industrial district in the early 1900s. The message on the card's back reads, "Arrived at Emporium at 12 o'clock, having a good time, going to Sizerville tomorrow." Sizerville, Cameron County, is located on Portage Creek a few miles north of Emporium on the current State Route 155.

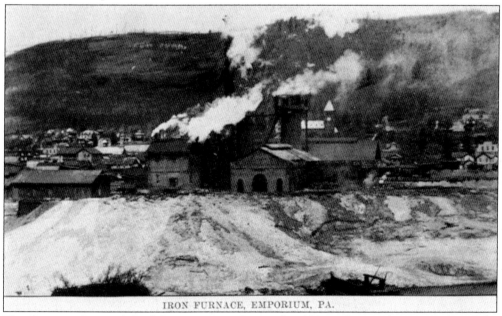

IRON FURNACE, EMPORIUM, PA.

The Cameron Iron and Coal Company was chartered in 1886 and opened two years later. The iron furnace, shown in this card postmarked 1909, had a stack that was 75 feet high and 16 feet in diameter. In the late 1800s, the furnace was producing 100 tons of iron daily, using a mix of Pennsylvania and New York ores. Historian J. D. Beers noted that in 1890, "There was not a more modern plant of the kind anywhere."

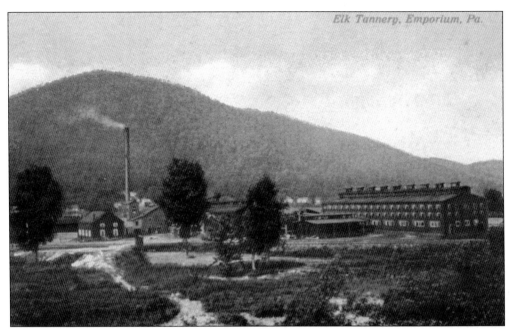

Work on the first tannery in Emporium commenced shortly after the town was founded. In 1888, the Emporium Tanning Company was chartered, giving "employment to a large force of men in all its departments." This card, postmarked 1916, shows a view of the Elk Tannery at Emporium.

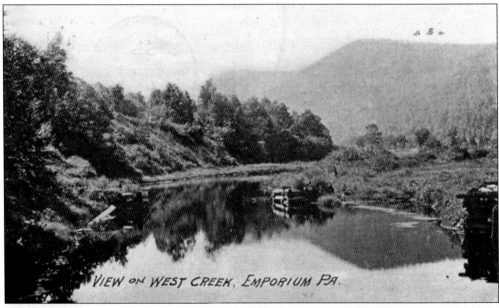

This card, postmarked 1911, shows a picturesque view on West Creek near Emporium. West Creek, along with Portage Creek, joins the Driftwood Branch of Sinnemahoning Creek at Emporium. Note the remainders of the wooden bracket dam on West Creek. During the early logging days, bracket dams were used to create a pool where logs could be floated and stored. Once enough logs were accumulated, the dam was released, sending a flood of water and logs downstream to the Driftwood Branch.

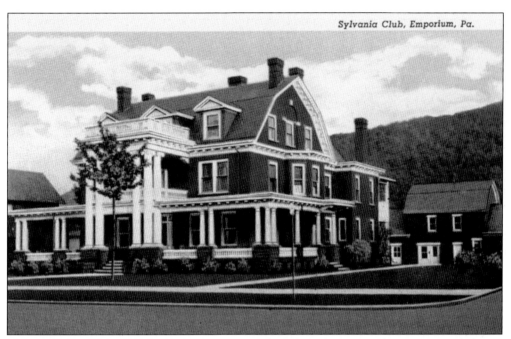

The Novelty Incandescent Lamp Company, which later became Sylvania, expanded into Emporium in 1924. The Sylvania plant at Emporium manufactured radio tubes and at its height employed over 1,600 workers. During World War II, women dominated the workforce at Sylvania, prompting a national magazine to name Emporium as "Girl's Town, USA." This card dated 1955 shows an image of the Sylvania Club in Emporium.

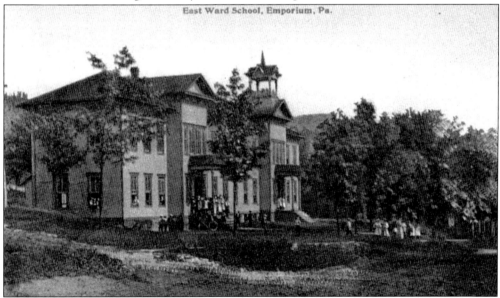

In the late 1800s, Emporium was divided into wards, East, West, and Middle, each with its own councilman, school director, judge of elections, and election inspectors. Wards also had their own schools, as seen in this image of the East Ward School, postmarked 1906. The message on the card's back reads, "Last Saturday we went out in the country and got about two bushels of butter nuts. Lawrence got seventeen chickens, we ate one. I am having boiled cabbage for dinner."

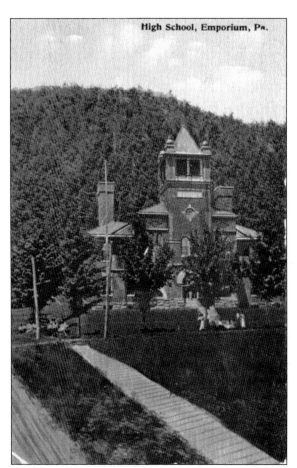

High School, Emporium, Pa.

An 1890 history of Emporium noted that "much attention is given to school affairs here, as may be gleaned from the record of directors elected annually, who are named in the pages devoted to municipal affairs." This attention to education can be seen in these two cards, which show changes in the town's high schools. The card at left, postmarked 1911, shows Emporium's high school in the early 1900s. The card below shows the high school in the 1920s.

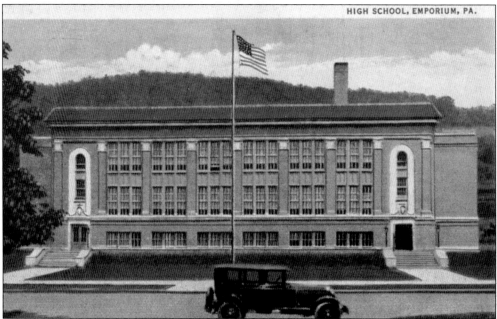

HIGH SCHOOL, EMPORIUM, PA.

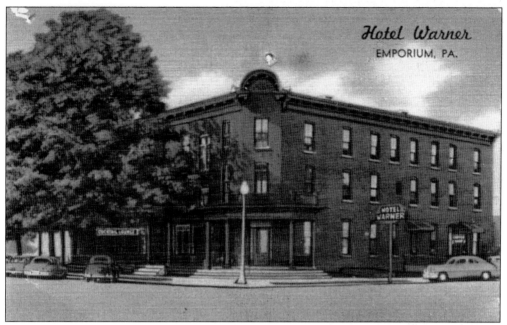

The Hotel Warner in Emporium was one of several accommodations that served travelers on the Bucktail Highway. The promotion on the back of this 1950s card reads, "Located in the heart of Pennsylvania's big game country. Pure mountain streams for trout and bass fishing. Some of the most beautiful scenery in the world. Air Conditioned Dining Room & Cocktail Lounge. Modern Rooms."

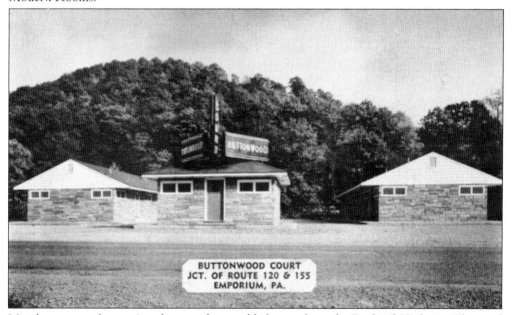

Motels were another option that travelers could choose along the Bucktail Highway. This card shows the Buttonwood Court at the junction of the Bucktail Highway and Route 155, which runs south from Port Allegany. The promotion on the back of this 1950s card reads, "A Modern Motel located in 'The Land of the Endless Mountains.' This also is the heart of Penn's Hunting, Fishing and Vacation Land. One of America's only All Electric Motels."

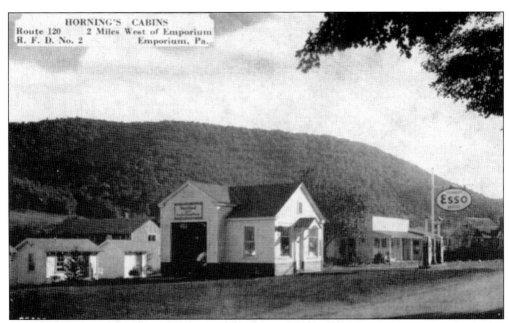

Cabins were a common option for many travelers and sportsmen who wanted to closely experience the local environment. This 1950s postcard shows Horning's Esso station cabins located two miles west of Emporium on the Bucktail Highway. The promotion on the card's back reads, "Cabins with all modern conveniences. Groceries, Meats, Vegetables and Fruits. In the Heart of Big Game Country. Hunters welcome."

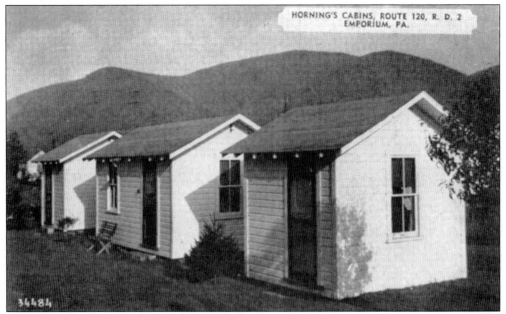

Accommodations such as Horning's Cabins near Emporium were popular with sportsmen who did not have access to private camps. The message on the back of this card, postmarked December 4, 1951, reads, "It is Monday evening and no deer shot today. It is warm up here. Just a little snow. I saw about 17 doe today."

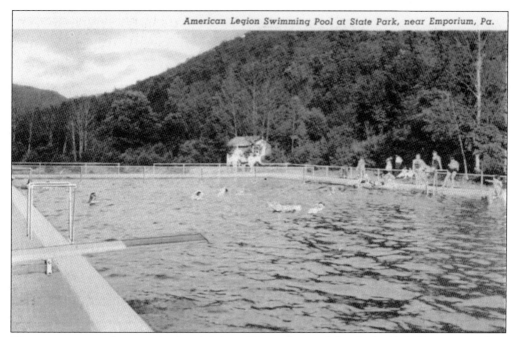

American Legion Swimming Pool at State Park, near Emporium, Pa.

Numerous state parks occur in the vicinity of Emporium and the Bucktail Highway, providing attractions and accommodations for travelers and tourists. This card shows one of the recreational draws: the American Legion swimming pool at a state park near Emporium.

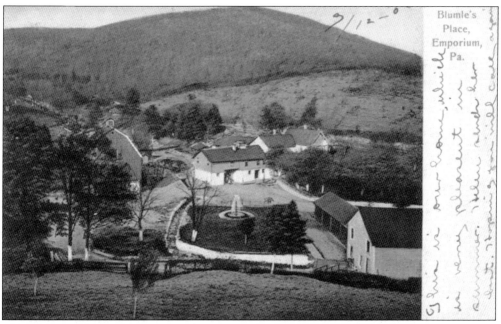

Blumle's Place, Emporium, Pa.

This card, postmarked 1908, shows a view of Blumle's Place near Emporium. Blumle's Place was a brewery established on Wright Run by F. X. Blumle in 1876. By the 1890s, the brewery of Blumle's Place had a capacity of about 500 barrels yearly. Blumle added a bottling works in 1882.

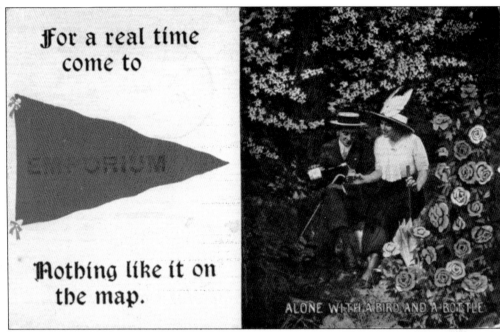

For a real time
come to

EMPORIUM

Nothing like it on
the map.

ALONE WITH A BIRD AND A BOTTLE

This Emporium "greetings" postcard, postmarked 1913, is captioned "Alone with a Bird and a Bottle." While the bottle in the man's hand is evident, the bird in the image is not. Look closely at the woman's hat. Use of bird parts or whole birds as millinery adornments was a common practice in Victorian times. The "plume trade" devastated many wild bird species until the practice was banned by federal law.

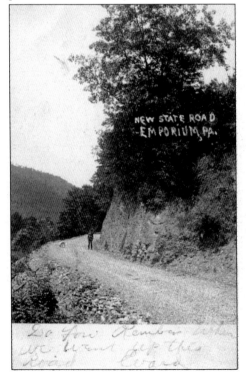

NEW STATE ROAD
EMPORIUM PA.

The few roads in and out of Emporium in the early 1900s varied greatly in condition and utility, including the Bucktail Highway. The image on this card, postmarked 1906, was taken near Emporium and is titled "New State Road." The message on the back of this card reads, "Do you remember when we went up this road?"

Four

DRIFTWOOD, SINNEMAHONING, AND BENNETT BRANCH

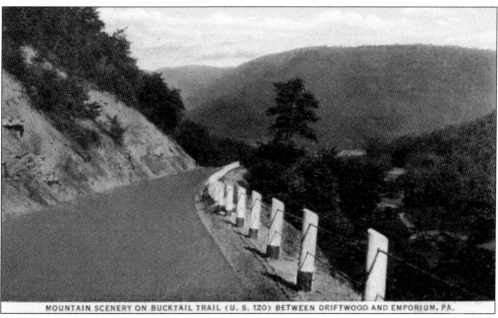

MOUNTAIN SCENERY ON BUCKTAIL TRAIL (U. S. 120) BETWEEN DRIFTWOOD AND EMPORIUM, PA.

The Bucktail Highway runs southeast from Emporium to Driftwood through the small settlements of Canoe Run, Cameron, and Huntley. Cameron was once a lumbering and mining town and was home to the Cameron Coal Company and the Hunt Run Lumber Company. The town and county were named for Simon Cameron, a dominant Republican and U.S. senator who also served as Abraham Lincoln's secretary of war and ambassador to Russia.

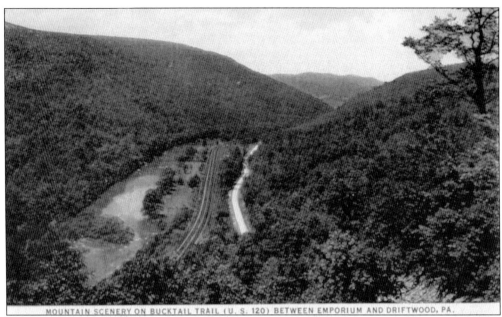

MOUNTAIN SCENERY ON BUCKTAIL TRAIL (U. S. 120) BETWEEN EMPORIUM AND DRIFTWOOD, PA.

The Sinnemahoning Path, a Native American trail, ran from Lock Haven up the West Branch of the Susquehanna River, and Sinnemahoning Creek to Emporium. The Bucktail Highway follows some of this path. From Emporium the path ran north up Portage Creek, crossing the Allegheny Front at Keating Summit, to Port Allegany. Native Americans called both Emporium and Port Allegany "Canoe Place," sites where canoes were left on the portage across the continental divide that separates the Susquehanna and Allegheny drainages.

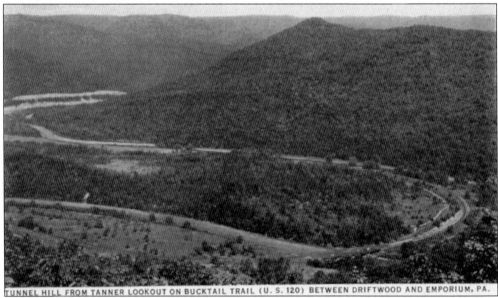

TUNNEL HILL FROM TANNER LOOKOUT ON BUCKTAIL TRAIL (U. S. 120) BETWEEN DRIFTWOOD AND EMPORIUM, PA.

The postcard titled "Tunnel Hill from Tanner Lookout on Bucktail Trail" shows the large meander loop of the Driftwood Branch in Elk State Forest upstream from Huntley. Huntley was named for George W. Huntley, a logger who cut timber for the Dodge and Goodyear families. The grade up the mountain here was steep and long, and runaway trains were not uncommon in the railroad logging days.

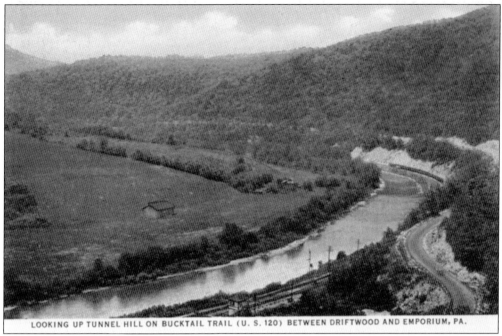

LOOKING UP TUNNEL HILL ON BUCKTAIL TRAIL (U. S. 120) BETWEEN DRIFTWOOD AND EMPORIUM, PA.

Huntley later was the site of a Civilian Conservation Corps camp for African Americans. This postcard, looking up Tunnel Hill on Bucktail Trail, shows a closer view of the Driftwood Branch meander upstream from Huntley.

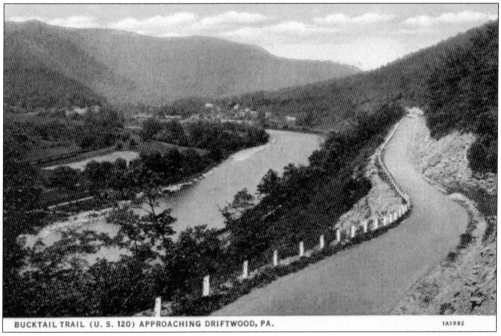

BUCKTAIL TRAIL (U. S. 120) APPROACHING DRIFTWOOD, PA. 1A1992

Driftwood was incorporated in 1872 and was called Second Fork as early as 1804 in reference to the junction of Bennett Branch with Driftwood Branch at the town. Driftwood was initially a lumber and river rafting town. Later the Allegheny Valley and Philadelphia and Erie Railroads joined at Driftwood in the early 1860s, and the town became a minor railroad center.

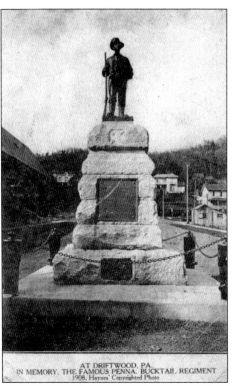

The Bucktail Highway gets its name from Pennsylvania's Bucktail Regiment of the Civil War. The volunteers from the regiment left Driftwood in April 1861 on rafts bound for Harrisburg. This card shows the monument erected at Driftwood to honor the Bucktail Regiment, a bronze statue of a young volunteer holding a rifle and wearing a buck tail on his hat—the regiment's emblem. The Bucktails were noted Union sharpshooters in the Civil War.

AT DRIFTWOOD, PA.
IN MEMORY, THE FAMOUS PENNA. BUCKTAIL REGIMENT
1906, Haynes' Copyrighted Photo

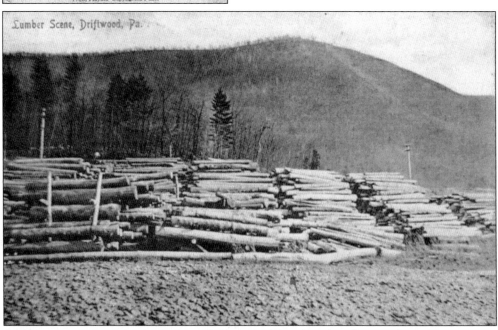

Lumber Scene, Driftwood, Pa.

Driftwood was named for the driftwood, likely unclaimed lumber that was floated downstream and would "hang up" at the Second Fork. During the lumber boom of the 1860s to 1870s, Driftwood had three hotels, two banks, several businesses, and churches. L. A. Gleason established a tannery here in the 1860s. The lumber shown in this card from Driftwood in the early 1900s is likely small in size compared to the virgin timber that once floated past the town.

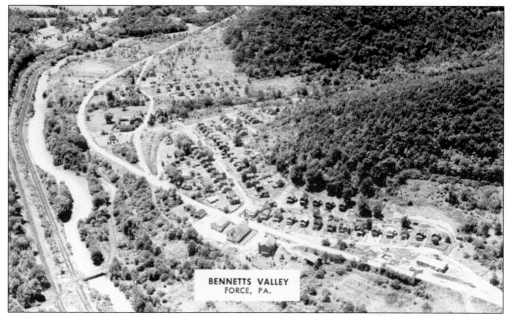

BENNETTS VALLEY
FORCE, PA.

Bennett Branch joins the Driftwood Branch at Driftwood to form Sinnemahoning Creek. Bennett Branch was probably named for John Bennett and his father, beaver trappers who built a cabin in the Bennett Valley around 1794. This card shows a bird's-eye view of the Bennett Valley at Force, Elk County. Force, started in 1903, was one of three mining villages built by the Shawmut Mining Company and was named after Jack Force.

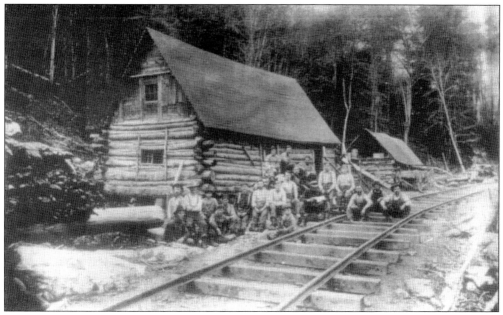

Medix Run, Elk County, consisted of a hotel, a few houses, and a store in 1892. In 1893, a lumber mill was completed at the village by the Medix Run Lumber Company. A tannery was built in 1894, and the Medix Run Railroad was incorporated in 1895. In 1902, the Goodyear Lumber Company bought the mill, railroad, and 20,000 acres of forest around Medix Run. This card shows a lumber camp along Medix Run in the early 1900s.

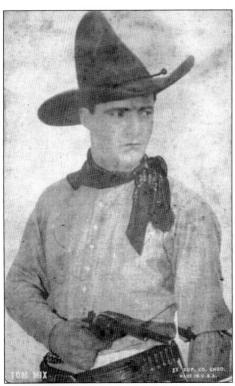

Tom Mix was a famous silent movie cowboy who was born at Mix Run along Bennett Branch in 1880. In all, Mix made 370 movies and starred in the classic silent film *The Great Train Robbery*. His father worked horses for John Dubois at Mix Run. Dubois built his fortune in lumber in the Susquehanna Valley. The city of Dubois, Clearfield County, is named for him.

BEAUTIFUL SCENE ON BUCKTAIL TRAIL (U. S. 120) NEAR SINNAMAHONING, PA.

Leaving Driftwood, the Bucktail Highway heads southeast approximately 20 miles to the village of Sinnemahoning, Cameron County. The land about Sinnemahoning was surveyed around 1805. In 1811, John Brooks purchased lands in the area and sold lots. In 1811, Brooks planted an apple tree at Sinnemahoning that was cut down in 1889 to make way for the Barclay Brothers hardware and furniture store. The historic tree was three feet, six inches in diameter when cut.

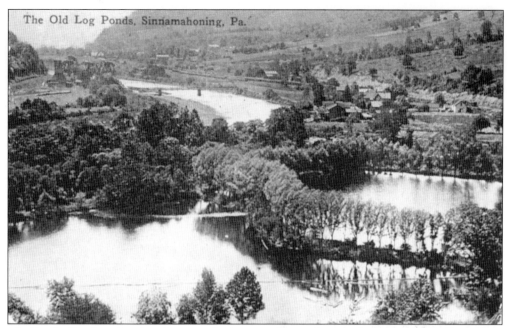

The Barclay Brothers Lumber Company built a sawmill near Sinnemahoning in 1881. The mill cut about 60,000 board feet of lumber daily but did not operate during the winter. In 1888, Barclay Brothers constructed a mill on Wykoff Run, an eighth of a mile above Sinnemahoning Creek. At this time the company employed "seventy-five men in the woods, bark-peeling and cutting timber." This early-1900s card shows a view of "the old log ponds, Sinnamahoning, Pa."

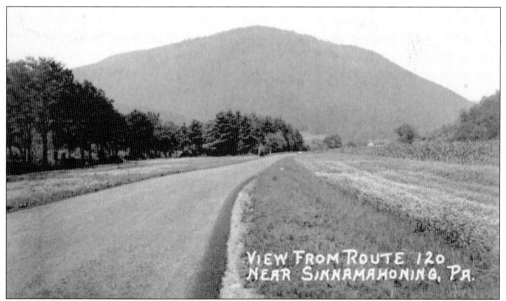

This early-1900s card shows a "View from Route 120 near Sinnamahoning." The Bucktail Highway is unpaved and passes through a mixed landscape of agriculture on the lower elevation flats and regenerating forests on the hilly uplands.

I'm carving my name all over Sinnamahoning, Pa.

And I'm the talk of the town.

The behavior of the woman on this card is unacceptable by today's standards. Sinnemahoning was known for wild behavior during its boom, as noted in this verse: "There is a place called Sinnemahone / of which but little good is known / for sinning, ill must be its fame / since sin begins its very name / so well indeed its fame is known / that people think they should begin / to drop the useless word Mahone / and call the country simply Sin."

High School, WESTPORT, PA.

I live on the left hand side X this building

From Sinnemahoning, the Bucktail Highway heads east through the village of Jericho. Near Keating, the West Branch of the Susquehanna River meets Sinnemahoning Creek. Westport, Clinton County, is located at the mouth of Kettle Creek. In 1862, the Philadelphia and Erie Railroad reached Westport. By 1875, Westport had a train station, a post office, a hotel, a school, a sawmill, and a Methodist church.

Five

RENOVO

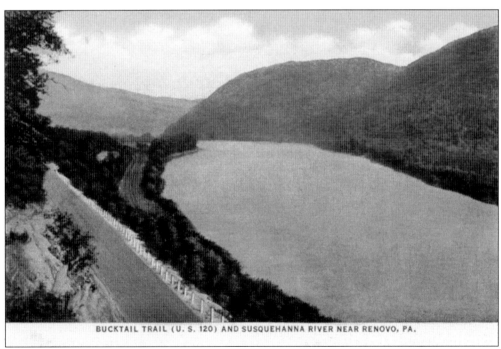

BUCKTAIL TRAIL (U. S. 120) AND SUSQUEHANNA RIVER NEAR RENOVO, PA.

From Westport, the Bucktail Highway continues east through the former logging villages of Shintown and Drurys Run. Drurys Run, just west of Renovo, once had two brick plants, each with its own railroad. Tamarack Swamp is located at the headwaters of Drurys Run. Tamarack Swamp was considered "a little oasis in the desert—the dense growth of hemlock, spruces and balsams and other heavy foliaged forest trees keeps out the hot rays of the summer sun."

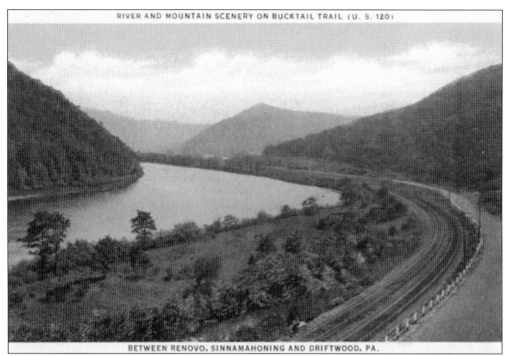

RIVER AND MOUNTAIN SCENERY ON BUCKTAIL TRAIL (U. S. 120)

BETWEEN RENOVO, SINNAMAHONING AND DRIFTWOOD, PA.

In this postcard view, the Bucktail Highway and railroad straddle sparse flatland along the river. It is unclear where this image was taken given the broad geographic range of the title "Between Renovo, Sinnamahoning and Driftwood, Pa." The image was probably taken closer in proximity to Driftwood and Sinnemahoning than to Renovo.

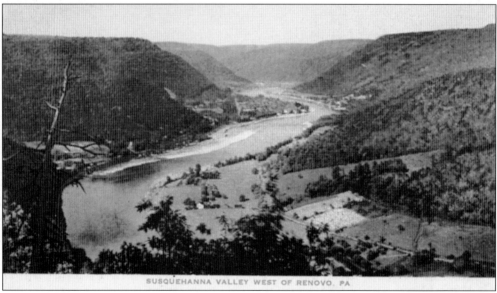

SUSQUEHANNA VALLEY WEST OF RENOVO, PA

Between Westport and Renovo, Dry Run, Shintown Run, and Drurys Run flow down to the West Branch of the Susquehanna River. This area was hard hit from past logging and mining, yet its forests and streams are recovering. For example, Drurys Run is considered to be an exceptional value stream by the Commonwealth of Pennsylvania for its outstanding water quality and aquatic life.

70

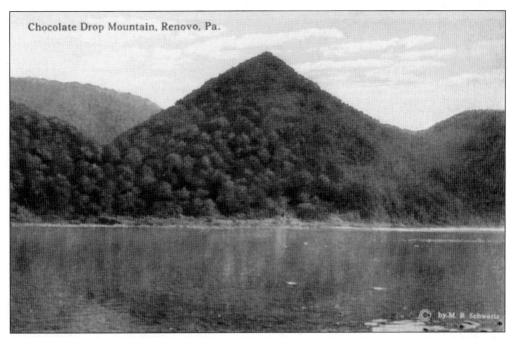

Chocolate Drop Mountain, Renovo, Pa.

© by M. B. Schwartz

Conical landforms, called "chocolate drops" by residents and travelers, are common along the Bucktail Highway. These montane chocolate drops are formed by erosion, which wears down the less-resistant flanks, leaving the hardened cap or cone.

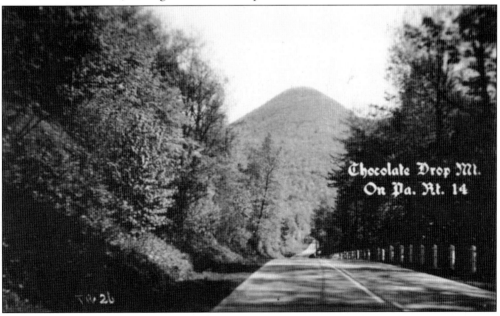

Chocolate Drop Mt.
On Pa. Rt. 14

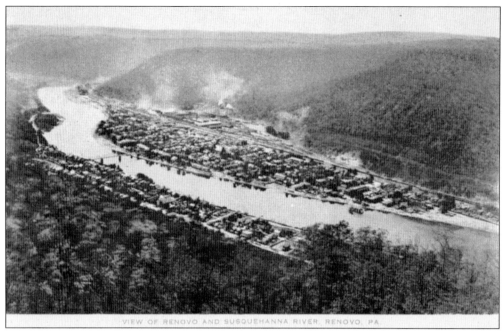

VIEW OF RENOVO AND SUSQUEHANNA RIVER, RENOVO, PA.

In 1785, a warrant for lands that would include Renovo was given to Samuel Byron. Byron's lands were divided into four districts in 1824, one of which was bought by William Baird, probably the first permanent settler in the area. In 1862, the Philadelphia and Erie Railroad reached the future Renovo and shaped the region's history. These two bird's-eye views of Renovo are from the early 1900s.

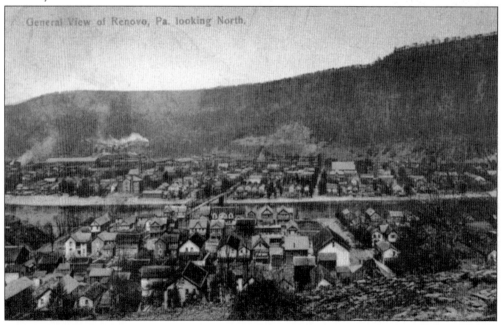

General View of Renovo, Pa. looking North.

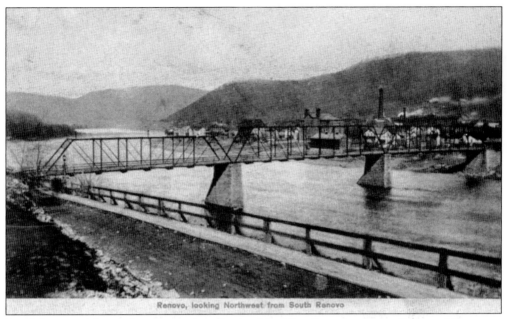

Renovo, looking Northwest from South Renovo

South Renovo is located on the southern bank of the West Branch opposite Renovo. These two images show bridges that connected the two boroughs. The image above shows an older truss bridge looking upstream from South Renovo. The image below shows the Memorial Bridge looking toward South Renovo. The Memorial Bridge was built in 1926.

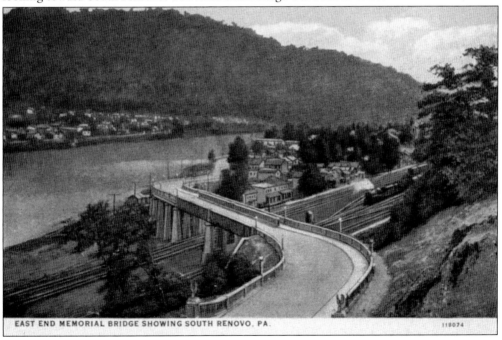

EAST END MEMORIAL BRIDGE SHOWING SOUTH RENOVO, PA. 118074

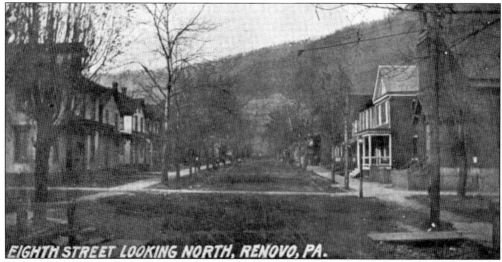

EIGHTH STREET LOOKING NORTH, RENOVO, PA.

Renovo was named in 1863 from the Latin for "renew." Lands not used by the railroad were divided into lots and made available for sale in 1864, primarily to rail workers. In 1864, the Philadelphia and Erie Railroad line was completed to Erie, and by 1865, the railroad station at the west of Renovo was completed. Renovo was incorporated in 1866. The two cards show some of Renovo's Eighth Street residences in the early 1900s.

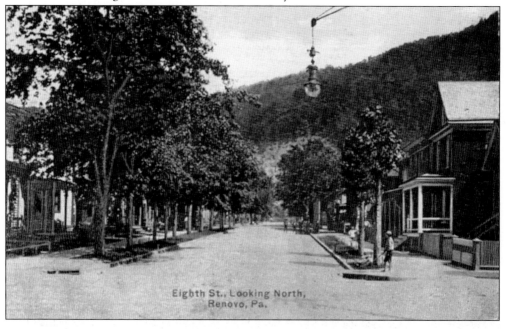

Eighth St., Looking North,
Renovo, Pa.

In 1883, historian William Egle found favorable things to say about Renovo: "The town is beautifully situated in a delightful valley, surrounded by high mountains on all sides. It contains three churches, eleven public schools, a public hall, a bank, and a weekly newspaper." These two postcards show residential areas of Renovo in the early 1900s.

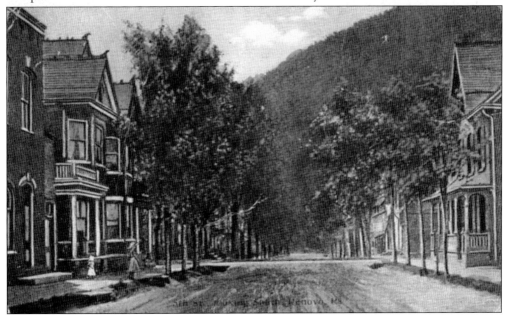

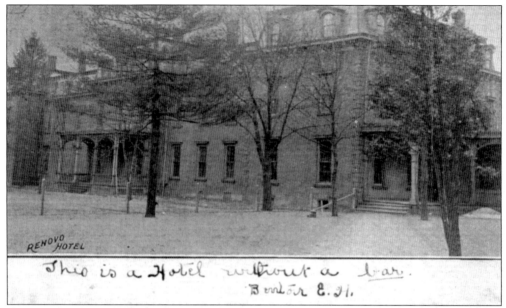

The Renovo Hotel (above) was built by the Philadelphia and Erie Railroad in 1869. The hotel was attached to the train station (below) and was considered an elegant stop for travelers in the late 1800s. A travel book published in 1875 noted that the Renovo Hotel was "a resort just suited to the hunter and fisher." The sender of this card showing the Renovo Hotel laments, "This is a Hotel without a bar."

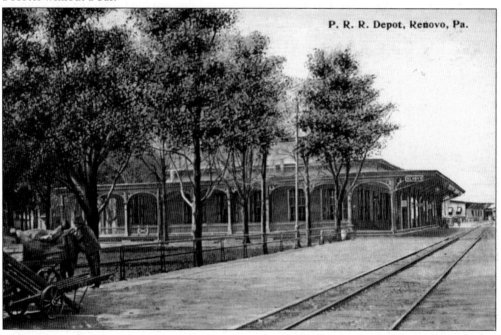

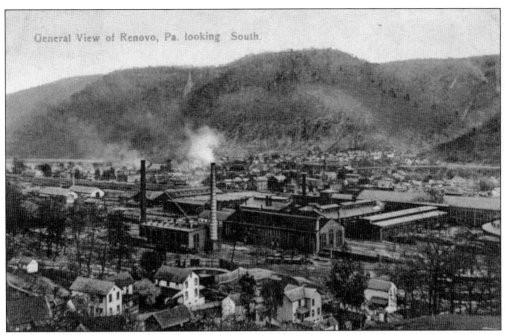

These two images show the vibrant Pennsylvania Railroad shops at Renovo in the early 1900s. Ground was broken for the new car shop in 1880 and for new passenger car and paint shops in 1881. In 1905, the shops were upgraded with machine shop, freight house, and timber shed in an interconnected plant. Also, a footbridge over the rail line was built from the rail shops to Erie Avenue, seen in the image below.

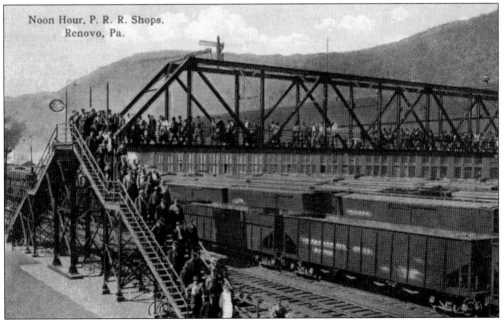

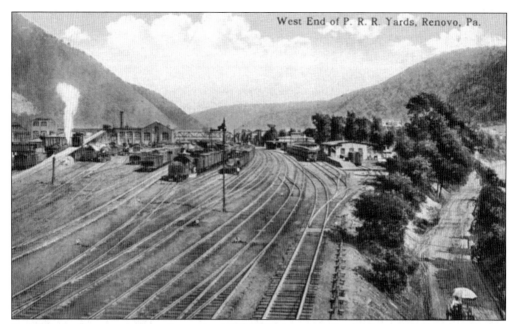

In 1923, the Renovo rail yards received $330,000 in upgrades. This included extending the Wend End Yards (above) and adding more storage tanks to the East End Yards (below). Another advance was the replacement of muddy service roads with stone driveways.

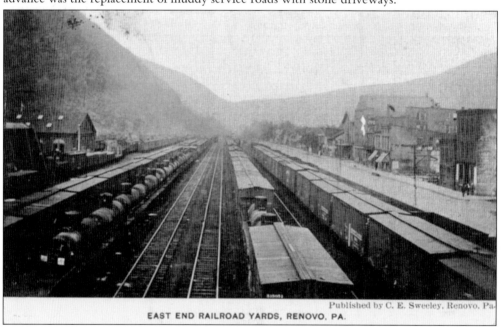

Published by C. E. Sweeley, Renovo, Pa.

EAST END RAILROAD YARDS, RENOVO, PA.

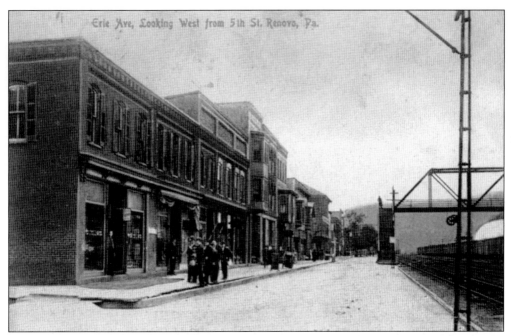

These two postcards from the early 1900s show Erie Avenue near the rail shops and depot. The Pennsylvania Railroad shops continued to grow at Renovo through the 1920s with the move of the company's air brake department to Renovo from Sunbury, Northumberland County. In 1953, the shops began to service diesel engines.

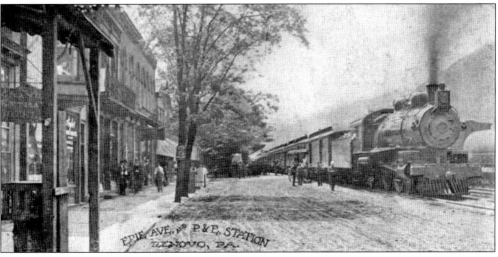

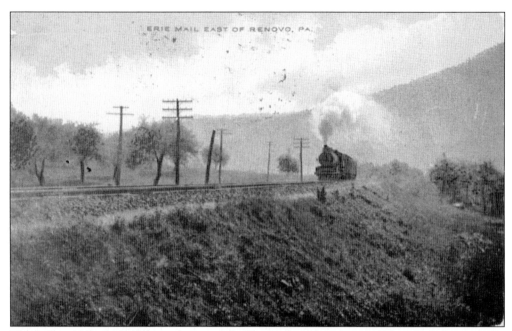

The industry that built Renovo began to decline in the 1960s, in parallel with the nationwide trend in declining rail services. In 1968, the Pennsylvania Railroad closed its shops in Renovo and moved to Altoona, Blair County. In 1969, the last passenger train left Renovo and an era ended. These two postcards from the early 1900s show the rail lines connecting Renovo with the outside world.

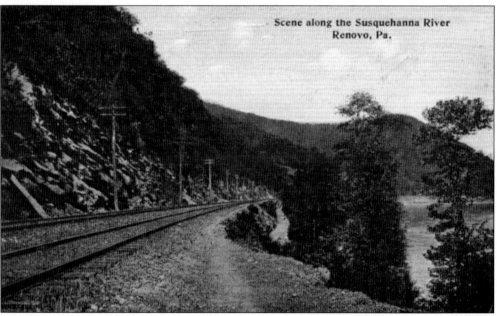

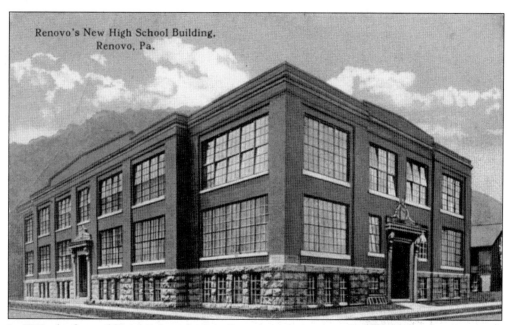

In 1873, the first public school was built in Renovo at the corner of Ontario Avenue and Seventh Street. This building was replaced in 1915. The school shown in this postcard is the 1915 school with wings added at each end.

In 1941 to 1942, during World War II, Harold Lehman, a painter, sculptor, and muralist, was asked to design a post office for Renovo. Lehman noted, "It happened that Renovo, Pennsylvania, was the center of a big locomotive repair operation of the Pennsylvania Railroad. The major thing they did was to repair locomotives, a very vital concern of the government during the war years." His design incorporated the concept that production for the war would help the country's allies.

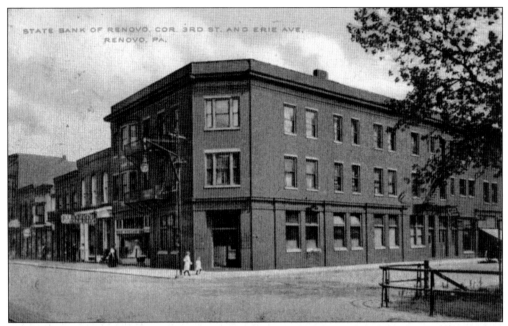

The Citizens Bank of Renovo opened in 1935 at Third Street and Erie Avenue. This postcard shows the bank with the name State Bank of Renovo instead of Citizens Bank.

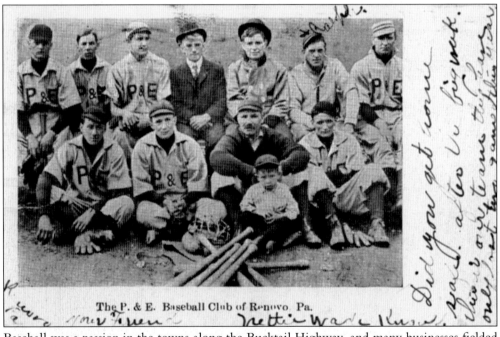

The P. & E. Baseball Club of Renovo, Pa.

Baseball was a passion in the towns along the Bucktail Highway, and many businesses fielded clubs, like the P&E Baseball Club of Renovo pictured in this early-1900s postcard. The P&E club was sponsored by the Philadelphia and Erie Railroad. Some of Renovo's local talent made it to the major leagues. Raymond Bloom "Rube" Bressler began with the Philadelphia Athletics in 1914. Bill Friel began with the Milwaukee Brewers in 1901. Joe Munson began with the Chicago Cubs in 1925.

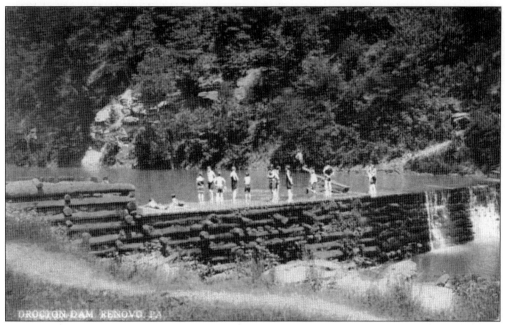

These two postcards show wooden bracket dams on streams in the Renovo area in the early 1900s, artifacts of the logging industry. Note the diving board and beach area in the image above of Drocton Dam. Drocton was once a village in Chapman Township, Clinton County, which is now part of Renovo Borough.

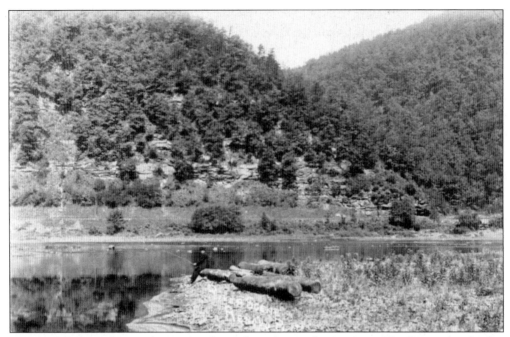

Renovo has always been a destination for anglers, the area having a wealth of exceptional value and high-quality cold-water fisheries with brook trout as the major species. Both Brewery Run and Paddy Run, which run through Renovo, are considered good trout streams. The card above shows a gentleman having some leisure time fishing on the West Branch near Renovo. The card below shows a "fine trout stream" near Renovo.

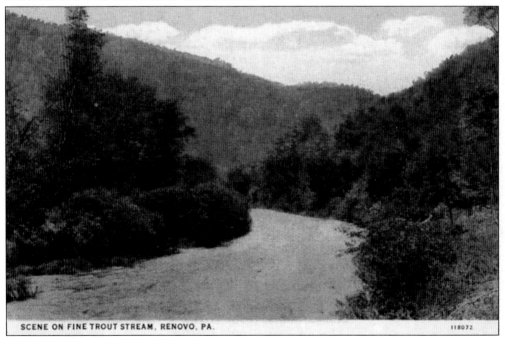

SCENE ON FINE TROUT STREAM, RENOVO, PA. 118072

Logging and mining and other land uses caused substantial changes in the forest and waters of the West Branch Valley. Loss of forest cover caused stream temperatures to rise and streams to become flood-prone during rain events. Soil eroding from bare hillsides choked stream life. Wildlife species were hunted to near extinction. All was not lost, however, and careful stewardship has allowed forests, streams, and wildlife to recover. Some, like white-tailed deer, shown below, may have become too successful.

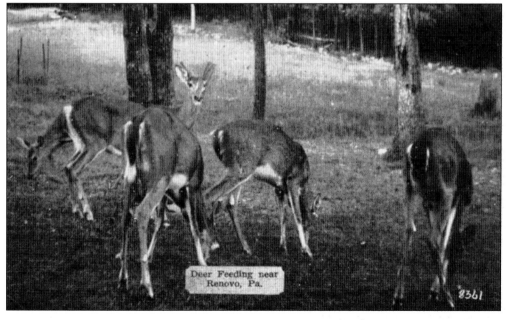

Deer Feeding near Renovo, Pa.

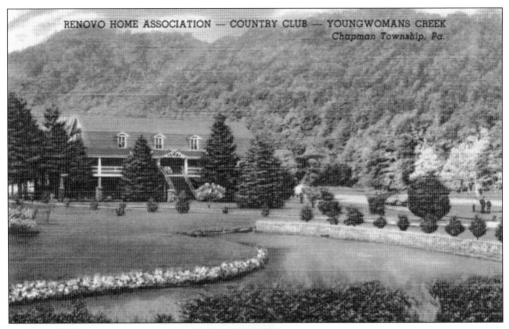

RENOVO HOME ASSOCIATION — COUNTRY CLUB — YOUNGWOMANS CREEK
Chapman Township, Pa.

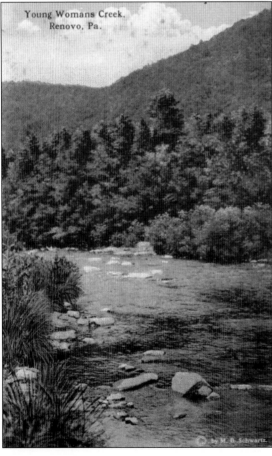

Young Womans Creek,
Renovo, Pa.

by M. B. Schwartz

The Renovo Home Association had a country club on Young Woman's Creek (above), east of Renovo, which afforded Bucktail Highway travelers food and lodging. Young Woman's Creek (at left), a high-quality cold-water fishery, was attractive to sportsmen and nature lovers alike. Much of the Young Woman's Creek watershed is contained within Sproul State Forest.

Six

NORTH BEND, GLEASONTON, AND HYNER

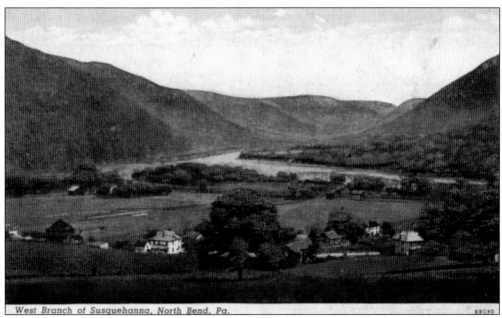

West Branch of Susquehanna, North Bend, Pa.

East from Renovo, the Bucktail Highway reaches the village of North Bend, once called Young Woman's Town, on Young Woman's Creek. Many myths center on the origins of name of the creek and former name of the village. One suggests that Native Americans killed a young woman at the spot, which was later avoided due to superstition. A Native American village existed at North Bend, which was called Mianaquaunk, perhaps meaning "place of meeting."

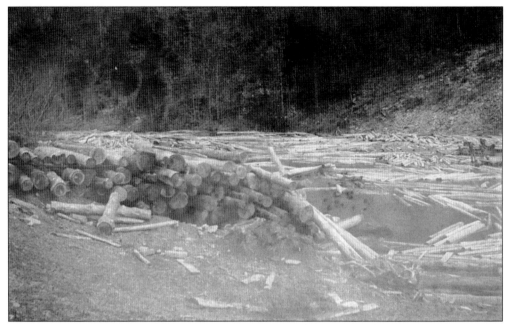

North Bend, Clinton County, was once a lumber town, but by the 1940s, it was supported by a tannery in adjacent Gleasonton and a clay products plant. The population then was about 400. The tannery was started in the late 1800s by the Gleason family, the owners of the large tannery at Medix Run along Bennett Branch, Elk County. This card from North Bend shows an image of what appears to be a pile of waste or kindling wood along with raw logs.

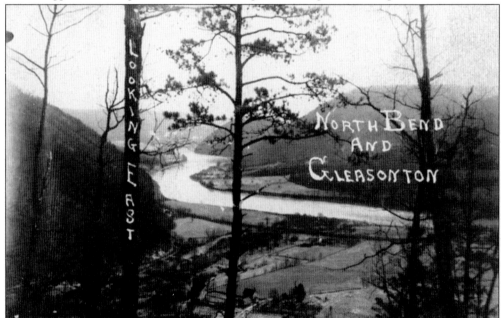

This striking image of the West Branch Susquehanna River Valley is labeled "North Bend and Gleasonton Looking East." Gleasonton was named after the Gleason family, owners of lumber and tanning concerns from Bennetts Branch to the Susquehanna River. Gleasonton is located adjacent to North Bend near the mouth of Young Woman's Creek.

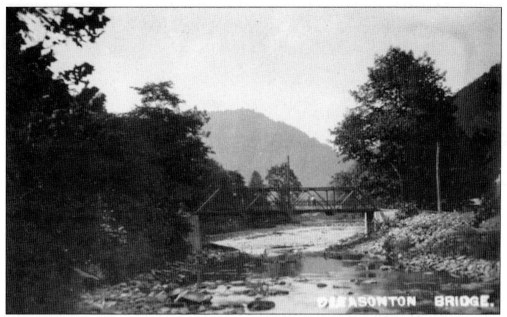

This card shows a view of Gleasonton Bridge that crossed Young Woman's Creek at Gleasonton. The Howard and Perley Company of Gleasonton owned 16,000 acres of forest in the area as well as the North Bend and Kettle Creek Railroad. Discontent with the lumber mills downstream at Williamsport led William Howard to build his own mill at Gleasonton. It initially operated from March to December, unusual for railroad-supplied mills, which generally operated year-round.

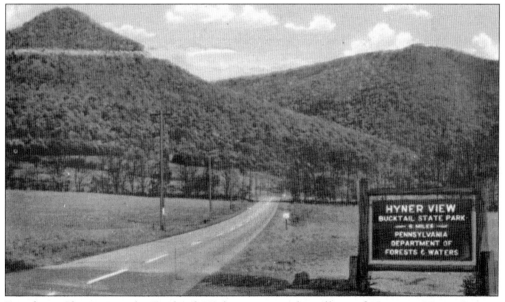

East from Gleasonton, the Bucktail Highway enters the village of Hyner at Hyner Run, a former logging village. Williams and Foresman Company owned the timber on Hyner Run. It also owned a small logging railroad on the run from which logs could be moved to cars on the Pennsylvania Railroad at Hyner and then to the mills at Williamsport. This card shows the access road to Hyner View, built in 1949.

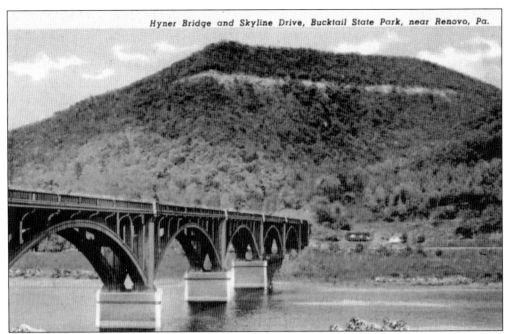

Hyner View, a state-owned overlook once part of the original Bucktail State Park, has since become Hyner View State Park. The overlook wall that provides views up and down the West Branch Susquehanna River Valley, seen in the distance in this image, was constructed in the 1930s by the Civilian Conservation Corps. Today's overlook is a favorite launch site for hang gliders.

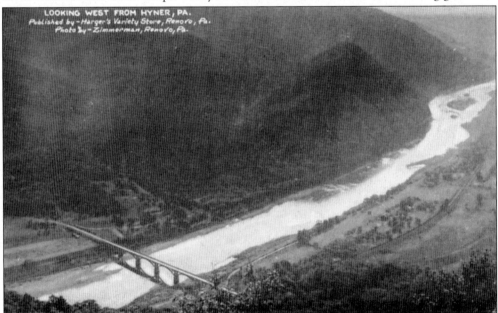

This card, published by Harger's Variety Store in Renovo is titled "Looking West from Hyner, Pa." and shows an outstanding view of the West Branch Susquehanna River Valley looking downstream from Hyner View. The Bucktail Highway crosses the bridge below and follows the south bank of the river to Lock Haven. The historic Sinnemahoning Trail would have followed the north bank of the river.

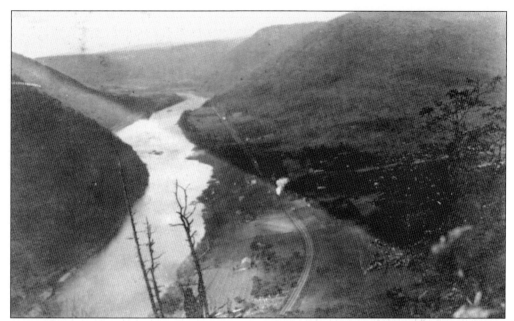

This postcard shows another view of the West Branch Susquehanna Valley near Hyner. The overlook at Hyner View State Park is at an elevation of 1,940 feet above sea level, and the river here is at an elevation of about 640 feet. Thus Hyner View is about 1,300 feet above the river valley. Note the close-cropped appearance of the forest, a product of the heavy logging of preceding decades.

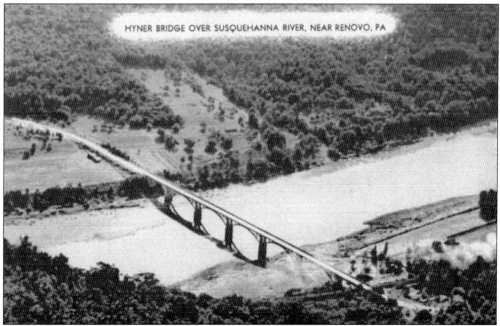

This 1930s linen postcard shows a view of the "Hyner Bridge over Susquehanna River, near Renovo, PA." The bridge was officially opened on October 15, 1930. The Flaming Foliage Festival began in 1949 and has been held at Hyner View to the present. In 1949, Sherrill Hiller of Jersey Shore was crowned queen.

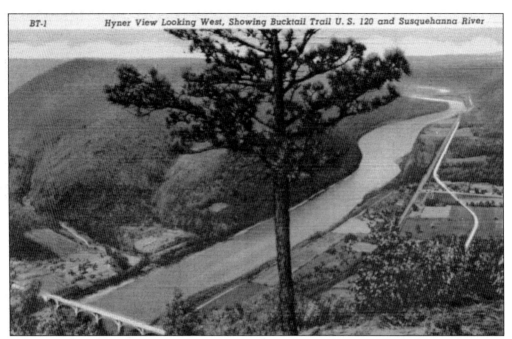

This image shows the Bucktail Highway heading west from Hyner and a portion of the Hyner Airport. The Hyner Airport operated in the 1920s to 1930s. It was an alternate mail route, was used by the Civilian Conservation Corps, and was used to fly emergency supplies to needed areas during the 1936 flood. Paul F. Maxwell, from Renovo, was among the first to use the airport at Hyner, flying his Parks airplane there in 1933.

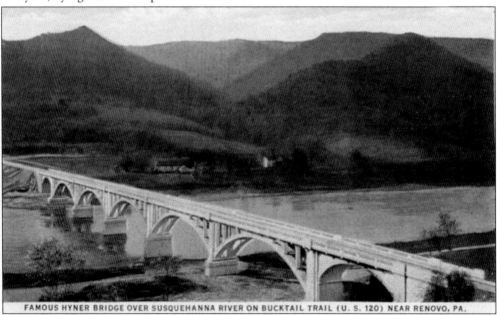

FAMOUS HYNER BRIDGE OVER SUSQUEHANNA RIVER ON BUCKTAIL TRAIL (U. S. 120) NEAR RENOVO, PA.

As noted in this postcard titled "Famous Hyner Bridge over Susquehanna River on Bucktail Trail," the Hyner Bridge is one of Pennsylvania's most well-known and most photographed bridges. Not surprisingly, with a large river system and many streams, Clinton County has a wealth of bridges. There are 243 bridges in Clinton County alone that are 20 feet or larger in length.

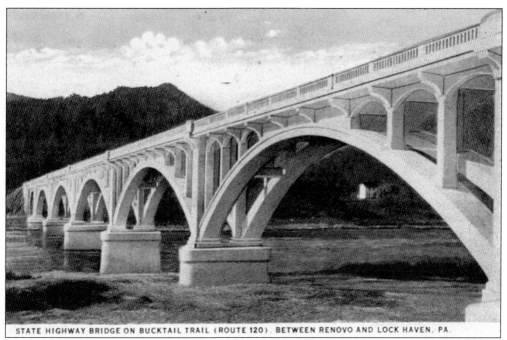

STATE HIGHWAY BRIDGE ON BUCKTAIL TRAIL (ROUTE 120), BETWEEN RENOVO AND LOCK HAVEN, PA.

The West Branch of the Susquehanna is a Pennsylvania water trail. Beginning at its headwaters near Cherry Tree in Indiana County and ending at its confluence with the North Branch at Sunbury, Northumberland County, the West Branch Water Trail is 228 miles long. The Pennsylvania Water Trails System currently includes 17 trails, providing rich experiences in river history, culture, and ecology, such as the Hyner View area seen in these two postcards.

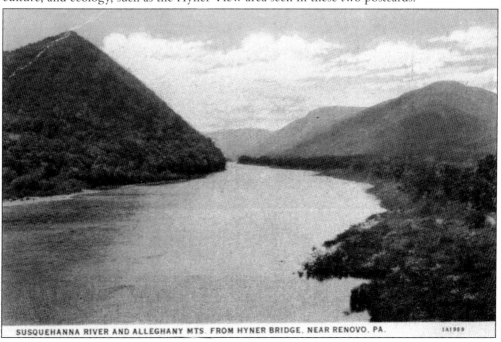

SUSQUEHANNA RIVER AND ALLEGHANY MTS. FROM HYNER BRIDGE, NEAR RENOVO, PA.

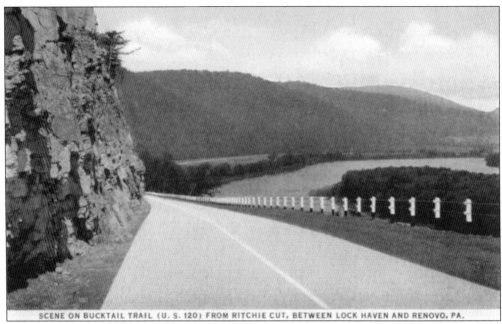

SCENE ON BUCKTAIL TRAIL (U. S. 120) FROM RITCHIE CUT, BETWEEN LOCK HAVEN AND RENOVO, PA.

This card shows a view of "Ritchie Cut, between Lock Haven and Renovo" on the Bucktail Highway in the 1940s. A "cut" is a place where the highway bed cuts into a slope. Ritchie, Clinton County, is a former logging village located at the mouth of Ritchie Run. Much of the wood cut in the area during the late 1800s and early 1900s was used for mine props that supported walls and ceilings of coal mines.

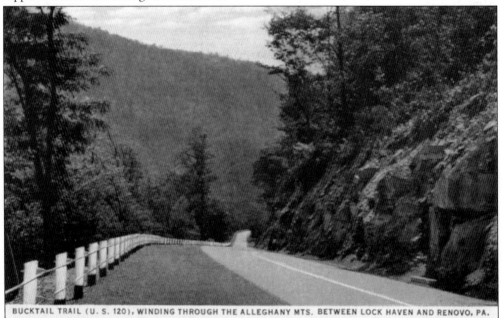

BUCKTAIL TRAIL (U. S. 120), WINDING THROUGH THE ALLEGHANY MTS. BETWEEN LOCK HAVEN AND RENOVO, PA.

Whetham, Clinton County, is a small settlement located on Rattlesnake Run downstream from Ritchie. Whetham is the site of an old fire tower and Civilian Conservation Corps cabin. The Rattlesnake Run valley is ecologically significant, supporting unique vernal wetlands. Of course, biological diversity was not a concern of early residents in the region.

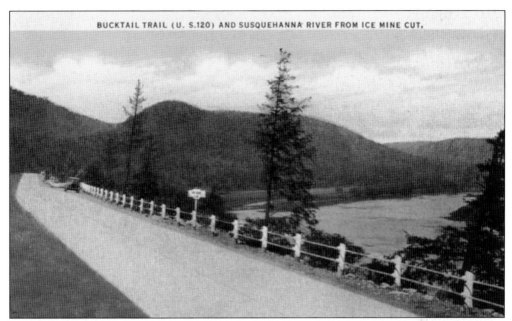

BUCKTAIL TRAIL (U. S.120) AND SUSQUEHANNA RIVER FROM ICE MINE CUT.

Downstream from Whetham is the small settlement of Glen Union, Clinton County. Glen Union is the site for the longest-operating logging railroad in Clinton County, owned by the Glen Union Lumber Company, which ran from 1889 to 1909. The company owned timber across the river on Mill Run and Baker Run, which was cut for mine props. An aerial cableway was used to move logs across the West Branch to the railroad at Glen Union.

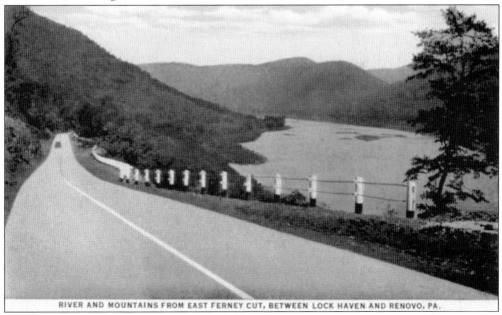

RIVER AND MOUNTAINS FROM EAST FERNEY CUT, BETWEEN LOCK HAVEN AND RENOVO, PA.

Ferney was another small logging village located downstream from Ritchie on Ferney Run. Mine props were also cut here. Daniel Shepp built a logging railroad up Ferney Run in 1890 to extract timber from his 1,474-acre parcel. The railroad was six miles long and had a number of side spurs. This card shows a view of "river and mountains from East Ferny Cut, between Lock Haven and Renovo."

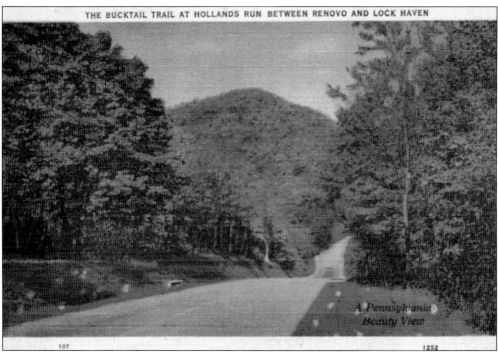

THE BUCKTAIL TRAIL AT HOLLANDS RUN BETWEEN RENOVO AND LOCK HAVEN

A Pennsylvania
Beauty View

Much of the land along the West Branch of the Susquehanna River is part of Sproul State Forest. Located in western Clinton and northern Centre Counties, Sproul State Forest contains 280,000 acres. The forest was named for William C. Sproul, governor of Pennsylvania from 1919 to 1923, who was an advocate of public education. Holland Run, seen above, is part of Sproul State Forest and crosses the Bucktail Highway opposite of Ferney.

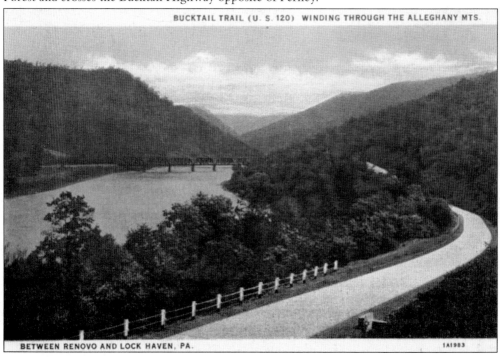

BUCKTAIL TRAIL (U. S. 120) WINDING THROUGH THE ALLEGHANY MTS.

BETWEEN RENOVO AND LOCK HAVEN, PA.

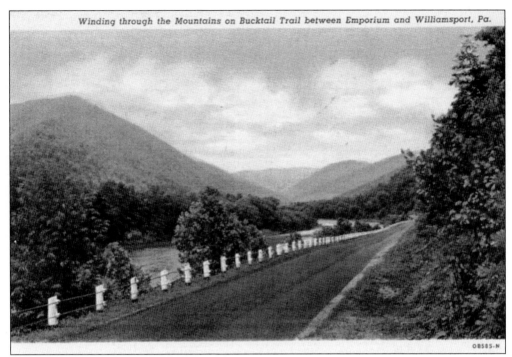

Winding through the Mountains on Bucktail Trail between Emporium and Williamsport, Pa.

OB585-N

In 1897, the Pennsylvania General Assembly passed legislation that authorized the purchase of "unseated lands for forest reservations for forest conservation." Acquisition of land for Sproul State Forest began in 1898 with the purchase of cutover lands in the Young Woman's Creek watershed near Bull Run. This was the purchase that began the state forest system in Pennsylvania, which now includes over two million acres.

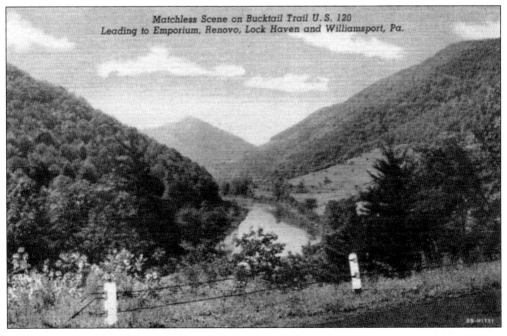

Matchless Scene on Bucktail Trail U. S. 120
Leading to Emporium, Renovo, Lock Haven and Williamsport, Pa.

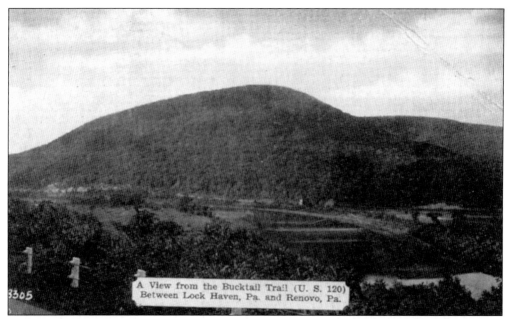

A View from the Bucktail Trail (U. S. 120)
Between Lock Haven, Pa. and Renovo, Pa.

3305

State parks such as Hyner View and Hyner Run are among the 27 parks located within 30 miles of the Bucktail Highway between Emporium and Lock Haven. The state park system in Pennsylvania began in 1893 with the purchase of Valley Forge State Park (now a national park) and today includes 61 parks in 67 counties. The growth of the state park was largely due to the efforts of Maurice K. Goddard, former long-term secretary of the Department of Forest and Waters.

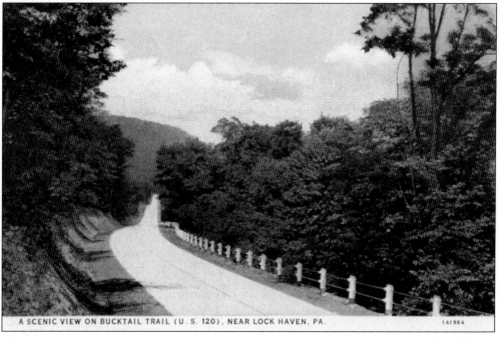

A SCENIC VIEW ON BUCKTAIL TRAIL (U. S. 120), NEAR LOCK HAVEN, PA.

1A1984

Seven

Lock Haven and Beyond

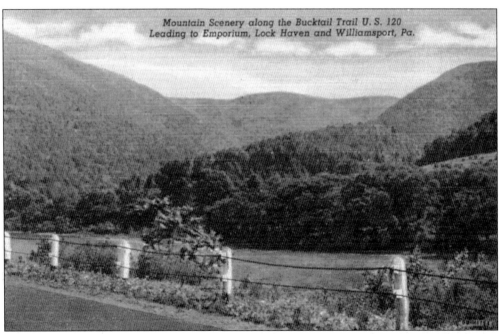

The Bucktail Highway continues east toward Lock Haven, in a valley of incomparable beauty. A 1940s travel guide notes, "Striking views are revealed at every turn in the winding roadway, which now hugs the face of a perilous stone cliff high above the river, and then swings down to the river edge. Tiny settlements dot the opposite shore. At intervals narrow dirt roads branch off to hunting camps deep in the forest."

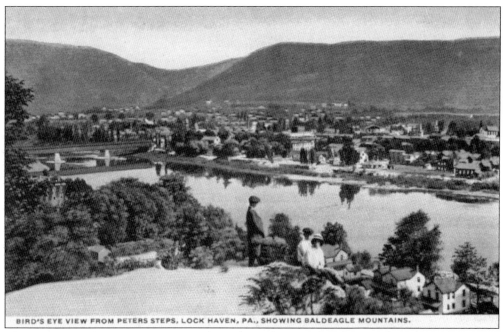

BIRD'S EYE VIEW FROM PETERS STEPS, LOCK HAVEN, PA., SHOWING BALDEAGLE MOUNTAINS.

The West Branch of the Susquehanna River flows east off the Allegheny Plateau near Lock Haven and enters the Ridge and Valley Province of Pennsylvania typified by long ridges of erosion-resistant sandstones and broad valleys of soft shales. Bald Eagle Mountain, the large ridge seen looking south in these two postcards, is the westernmost ridge of the Ridge and Valley Province in the Appalachian Mountains.

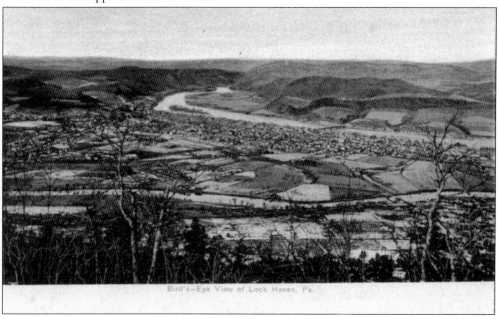

Bird's-Eye View of Lock Haven, Pa.

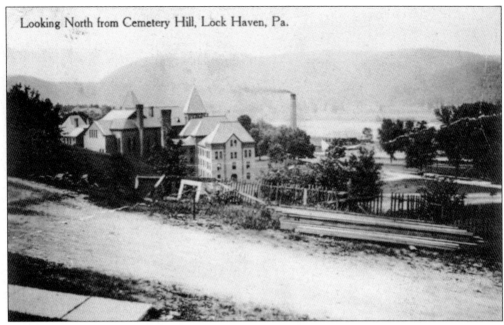

Looking North from Cemetery Hill, Lock Haven, Pa.

These two cards picture opposite sides of the West Branch Valley around Lock Haven. The card above, titled "Looking North from Cemetery Hill, Lock Haven, Pa.," shows a view north across the river toward Lockport. The card below, titled "Lock Haven, from Lockport Shore, Pa.," shows a view south toward Lock Haven.

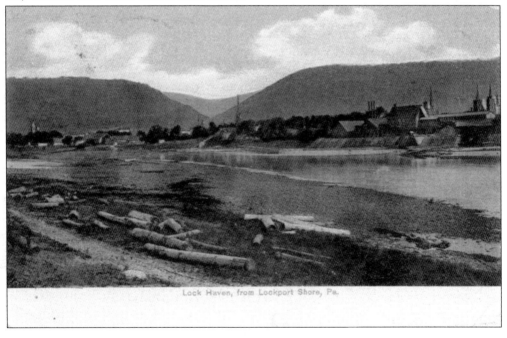

Lock Haven, from Lockport Shore, Pa.

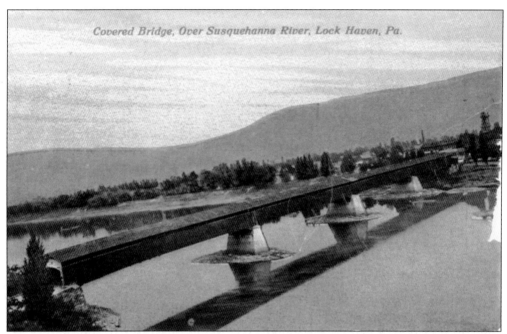

Covered Bridge, Over Susquehanna River, Lock Haven, Pa.

These two cards show views of the covered bridge that once crossed the West Branch of the Susquehanna River at Lock Haven. Tremendous amounts of wood went into building and maintaining this bridge over the years.

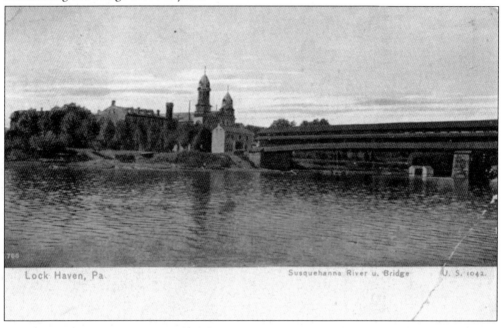

Lock Haven, Pa. Susquehanna River u. Bridge U. S. 1042.

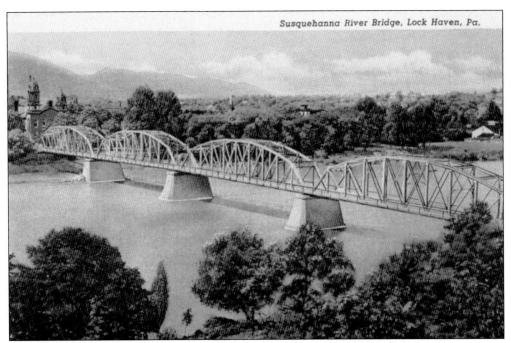

The wooden covered bridge across the West Branch at Lock Haven was first replaced by a four-span truss bridge (above) and later the cement Constitution Bridge.

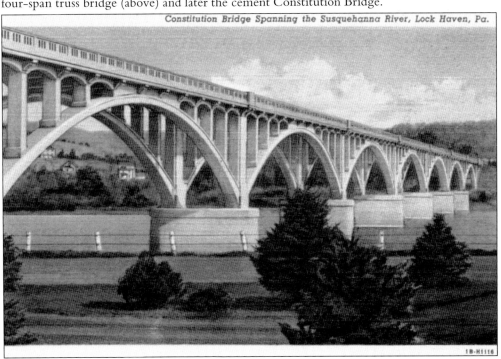

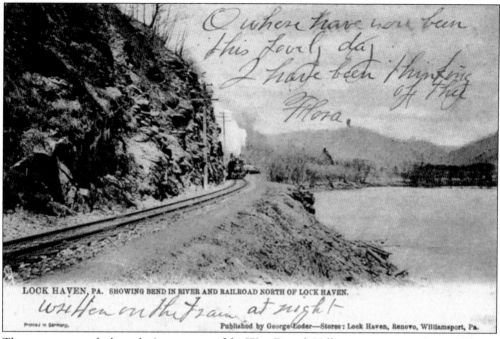

O where have you been this lovely day. I have been thinking of thee Flora.

LOCK HAVEN, PA. SHOWING BEND IN RIVER AND RAILROAD NORTH OF LOCK HAVEN.

Written on the train at night

Printed in Germany.　　　　　　　　Published by George Loder—Stores: Lock Haven, Renovo, Williamsport, Pa.

These two postcards show the importance of the West Branch Valley as a transportation corridor in the early 1900s. The card above is titled "Lock Haven, Pa. Showing Bend in River and Railroad North of Lock Haven." Note the Pennsylvania Railroad engine belching steam rounding the bend. The cards below depicts "Riverside road" on the south bank of the West Branch near Lock Haven. During high water, the road was doubtlessly impassable.

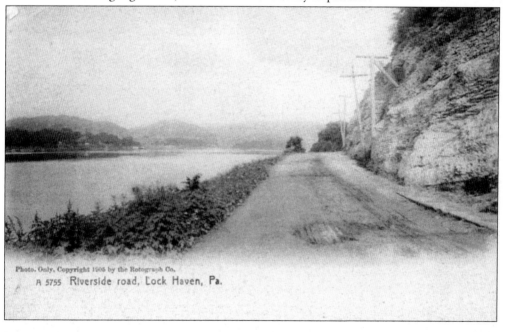

Photo. Only, Copyright 1905 by the Rotograph Co.

A 5755　Riverside road, Lock Haven, Pa.

The West Branch Valley near Lock Haven has always been awe-inspiring, as depicted in these two postcards. William Egle noted in 1883 that "there are several beautiful and highly productive valleys within the limits of the [Clinton] county, the most important being the West Branch . . . the West Branch of the Susquehanna . . . breaks through the Allegheny mountain, which at this point seems to lose much of its loftiness, as if in courtesy to the beautiful stream."

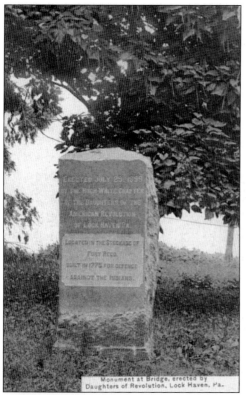

Fort Reed was constructed in present-day Lock Haven along Water Street by William and Jenny Reed to defend against frontier attacks by Native Americans during the American Revolution. It was abandoned in 1778, during the "Great Runaway" when many families fled the deadly frontier conflict. This card shows the monument, which states, "Erected July 29, 1899 by the Hugh White Chapter of the Daughters of the American Revolution . . . [and] Located in the Stockade of Fort Reed."

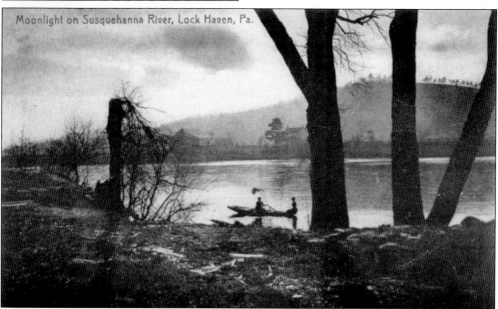

This card, titled "Moonlight on Susquehanna River, Lock Haven, Pa.," shows a bit more than a pretty scene. Note the flood-pruned tree in the left of the image, evidence of powerful high water. Lock Haven has been subject to many floods over the years, including those of 1889, 1936, and 1946. After the flooding caused by Tropical Storm Agnes in 1972, federal flood relief was sought, culminating in the levees that separated the town from the river in 1995.

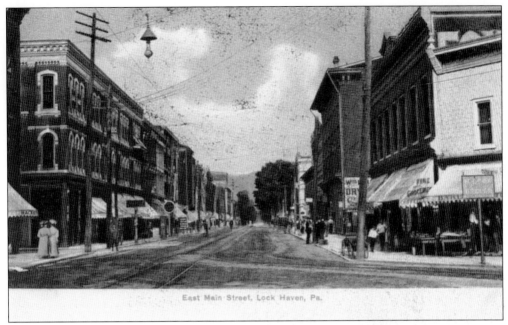

East Main Street, Lock Haven, Pa.

Lock Haven, the seat of Clinton County, was founded in 1833, incorporated as a borough in 1844, and incorporated as a city in 1870. Clinton County was founded in 1839 and was named for DeWitt Clinton, United States senator and governor of New York who was a strong proponent of the Erie Canal. Lock Haven was near the West Branch Division of the Pennsylvania Canal and gained its name from its location.

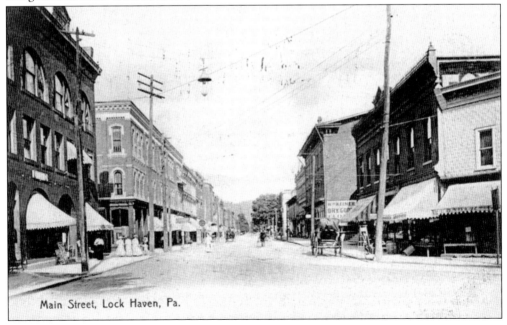

Main Street, Lock Haven, Pa.

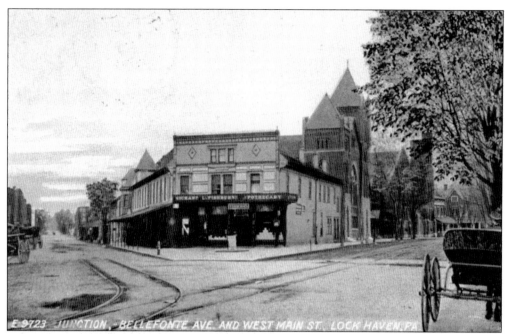

These two postcards from the early 1900s show the changing character of the triangle at the corner of Bellefonte Avenue and West Main Street in Lock Haven, before (above) and after (below) placement of the Civil War monument.

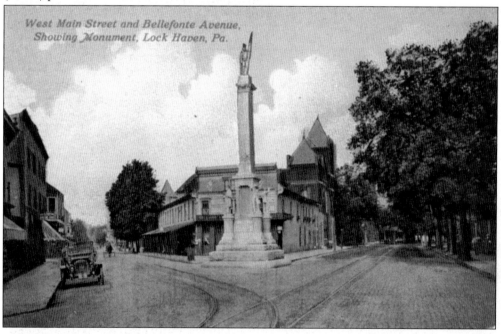

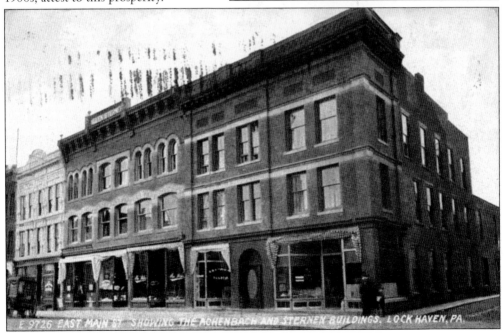

Bellefonte Avenue, showing Monument, Lock Haven, Pa.

In 1883, historian William Egle observed that Lock Haven had "sixty streets, the aggregate length of which is over twenty-five miles, and more than two hundred business places, thirteen church structures, and fourteen church organizations. It has fifteen secret societies, and four fire companies, three banks, and four printing offices, each issuing a weekly newspaper." These images of Bellefonte Avenue (at right) and East Main Street, from the early 1900s, attest to this prosperity.

E 9726 EAST MAIN ST. SHOWING THE ACHENBACH AND STERNEX BUILDINGS, LOCK HAVEN, PA.

Although the early prosperity of Lock Haven, seen in these early-1900s images, was due in large part to its location on the West Branch of the Susquehanna River, and also its proximity to the West Branch Canal, railroads were also important. The Tyrone and Lock Haven Railroad reached Lock Haven in 1857. Tyrone, Blair County, was on the Pennsylvania Railroad main line while Lock Haven was on the Philadelphia and Erie line.

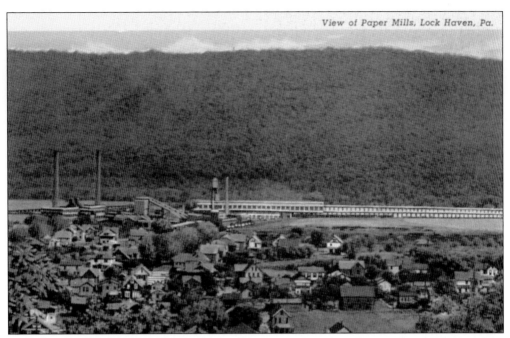

View of Paper Mills, Lock Haven, Pa.

The Curtis Publishing Company had a paper mill in Lock Haven that employed 1,000 workers at its peak. The company was formed in 1821 by Cyrus Curtis and became one of the largest publishers in the United States, publishing magazines such as *Ladies Home Journal* and the *Saturday Evening Post*. Financial troubles beginning in 1961 caused Curtis Publishing to sell its plant to Hammermill in 1965.

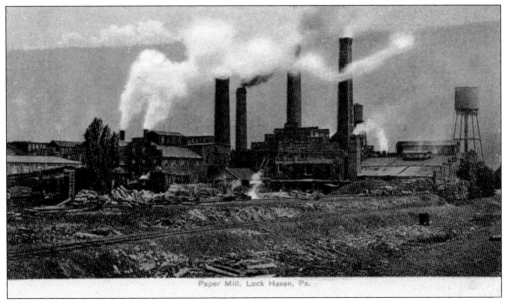

Paper Mill, Lock Haven, Pa.

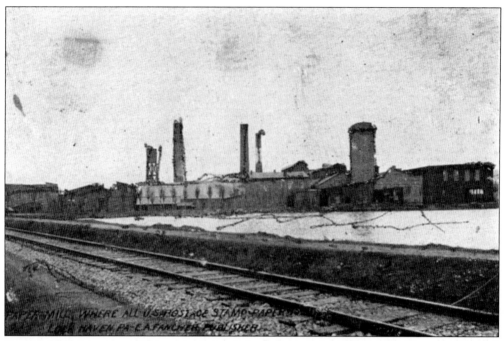

Besides the Curtis paper mill (seen in the card above, around the 1890s), Lock Haven had several other industries, as noted in a 1940s history, including "a textile mill, a chemical plant, a furniture factory, a tannery, a number of metal-products factories, and railroad repair shops." There was no mention of the Clinton Clay Company, whose kilns are shown in the image below from 1910. Many brick companies faltered after the introduction of cinder building blocks.

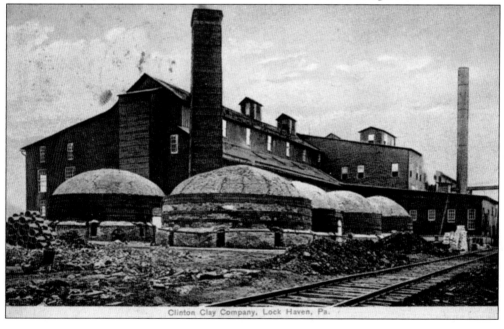

Clinton Clay Company, Lock Haven, Pa.

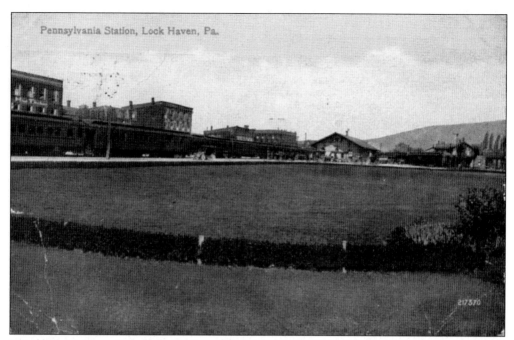

The Philadelphia and Sudbury Railroad completed Lock Haven's railroad depot along Clinton Street in 1859. The company lacked funds to continue construction on its rail line and reorganized in 1861 as the Philadelphia and Erie Railroad. The Pennsylvania Railroad subsidized building the line in exchange for a 999-year lease. These two cards show the Pennsylvania Railroad station (above) and passenger depot (below) in the early 1900s.

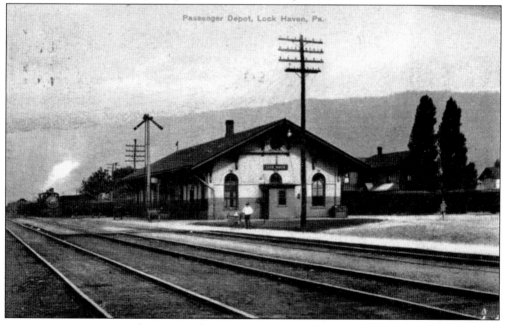

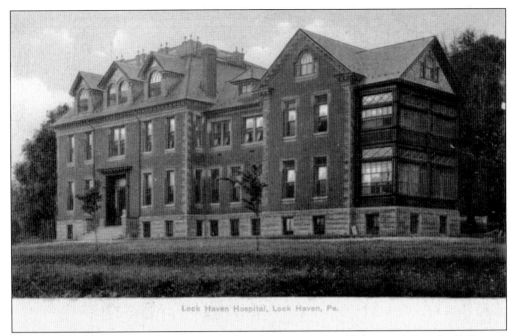

Lock Haven Hospital, Lock Haven, Pa.

Service infrastructure grew in Lock Haven over the years along with its population. Lock Haven's population in 1870 was 6,786, and in 2000, the population was 9,149. These two early-1900s postcards show the Lock Haven Hospital (above) and the First Ward School building (below).

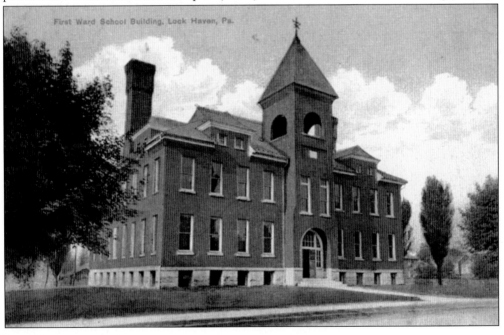

First Ward School Building, Lock Haven, Pa.

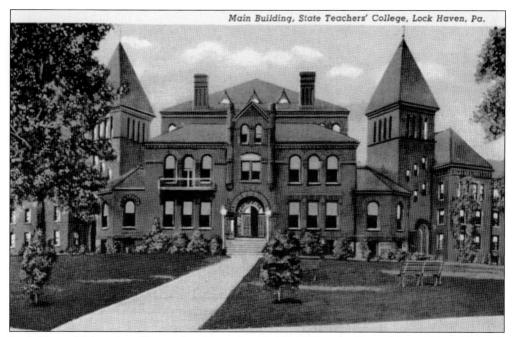

Main Building, State Teachers' College, Lock Haven, Pa.

Lock Haven University of Pennsylvania was founded in 1870 as the Central State Normal School, a private corporation for teacher preparation. The school was conveyed to the Commonwealth of Pennsylvania in 1914. The school has had several name changes. In 1926, it became the State Teachers College at Lock Haven, Lock Haven State College in 1960, and Lock Haven University of Pennsylvania in 1983. These two cards show Lock Haven's main building in the early 1900s.

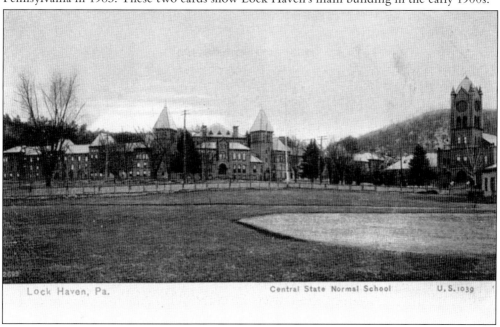

Lock Haven, Pa. Central State Normal School U.S. 1039

115

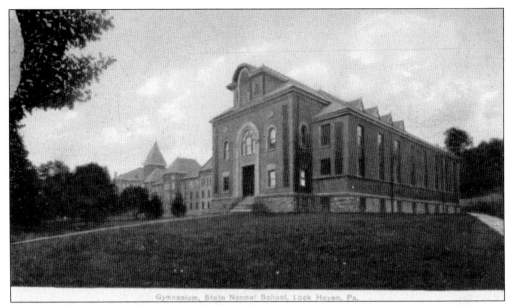

Gymnasium, State Normal School, Lock Haven, Pa.

A normal school was an educational institute for training teachers with the goal of establishing teaching standards or norms, from which the name is derived. The Normal School Act of 1857 empowered Pennsylvania to establish normal schools for training teachers. This was followed by the School Code of 1911, which mandated the commonwealth's purchase of the normal schools. This card shows the "gymnasium, state normal school, Lock Haven, Pa." shortly after passage of the 1911 code.

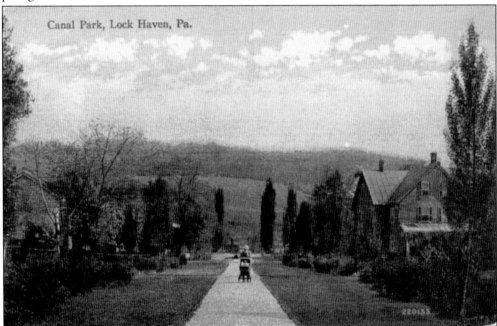

Canal Park, Lock Haven, Pa.

This card from the early 1900s shows a view of Canal Park in Lock Haven. The park was constructed on the site of the Bald Eagle Cross-cut Canal, which was part of the West Branch Division of the Pennsylvania Canal. The Bald Eagle Cross-cut Canal connected Bald Eagle Creek with the West Branch of the Susquehanna River. The great flood of 1889 destroyed the canal.

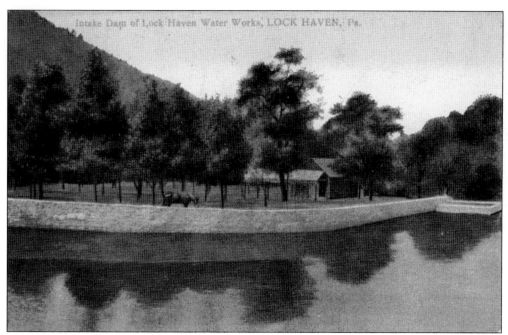

Lock Haven derives its drinking water from the Keller Reservoir located in the town of McElhattan on McElhattan Run. A 1907 account of Pennsylvania forests noted the importance of forested lands in maintaining the quality and quantity of drinking water and notes that a large portion of the McElhattan Run watershed belonged to the state. Much of the watershed today is contained within Bald Eagle State Forest. These two cards show the water intake (above) and waterworks (below) along McElhattan Run.

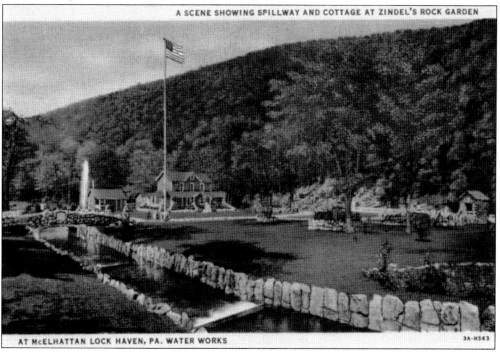

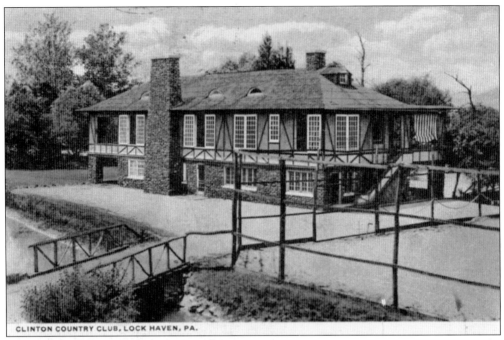

CLINTON COUNTRY CLUB, LOCK HAVEN, PA.

The Clinton Country Club was founded in 1908. Located on Fishing Creek in Mill Hall, the club currently sports a quality 18-hole golf course. These two cards show the original clubhouse at the Clinton Country Club.

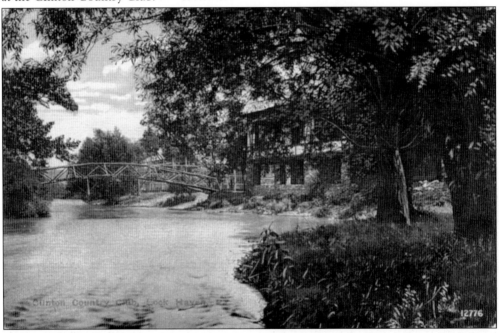

Many Native American paths converged at Lock Haven, which was known as Great Island for the large island in the West Branch just east of the city. These paths came from all directions and showed the importance of the West Branch as a travel corridor. The Sinnemahoning Path linked to the other paths at Great Island. This card shows an image of "River Road" at Lock Haven in the early 1900s that was likely built on an old Native American path.

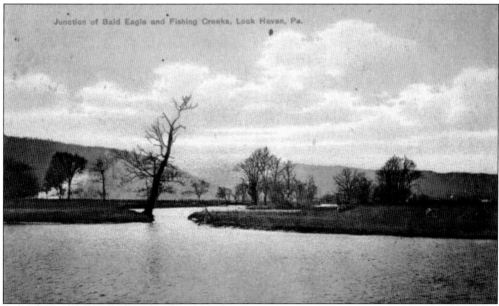

This card shows the "junction of Bald Eagle and Fishing Creeks" near Lock Haven. Bald Eagle Creek rises in the Ridge and Valley Province south of the West Branch in Centre County. Fishing Creek meets Bald Eagle Creek near the town of Flemington. Mining along the West Branch created mine drainage that acidified much of the river. Bald Eagle Creek flows through limestone on its journey to the West Branch and contributes badly needed alkalinity, which helps neutralize the mine acids.

Scene along Bald Eagle Creek, Lock Haven, Pa.

Bald Eagle Creek flows through the towns of Flemington and Castanea before joining the West Branch of the Susquehanna River to the east of Great Island. The Bald Eagle Creek Path passed along Bald Eagle Creek, linking Frankstown on the Juniata River to the south with Great Island. It was part of a warrior's path used by the Six Nations Iroquois to travel to Virginia and the Carolinas from New York.

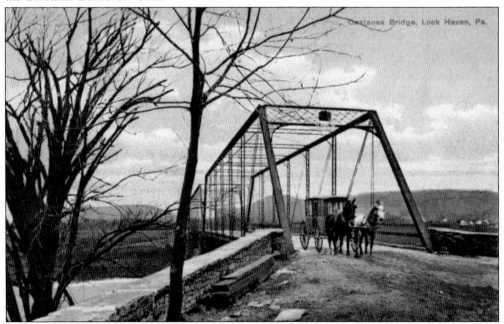

Castanea Bridge, Lock Haven, Pa.

Bald Eagle Creek was named not for the national symbol but for the Munsee Delaware chief Woapalanne, or Bald Eagle. Bald Eagle had his village at Milesburg, Centre County, called Bald Eagle's Nest. This card from the early 1900s shows an image of the Castanea Bridge crossing Bald Eagle Creek near Lock Haven. Castanea is the Latin name for "chestnut."

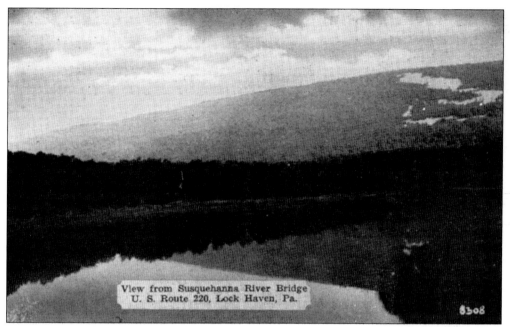

View from Susquehanna River Bridge
U. S. Route 220, Lock Haven, Pa.

8508

The Bucktail Highway ends at Lock Haven and connects with U.S. Route 220, shown in this postcard. U.S. 220 connects the Bucktail Highway with Jersey Shore and Williamsport to the east and the state college and Altoona to the south. A 1940s travel guide notes that U.S. 220 "parallels creeks and rivers, touching both branches of the Susquehanna River and following them for considerable distances."

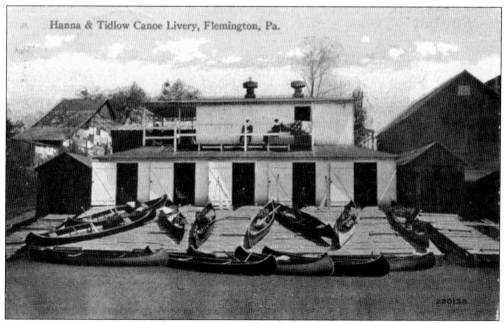

Hanna & Tidlow Canoe Livery, Flemington, Pa.

This card shows an image of the Hanna and Tidlow Canoe Livery in Flemington in the early 1900s. The livery was on the West Branch Canal. The West Branch Canal was authorized in 1828 and completed six years later. It was bought out by the Philadelphia and Erie Railroad in 1859.

121

Mill Hall was laid out in 1806 by Nathan Harvey and became a borough in 1850. Its population in 1883 was about 500. This grew to about 1,500 people in 2000. These postcards show Fishing Creek flowing through Mill Hall (above) and Church Street in Mill Hall (below) during the early 1900s.

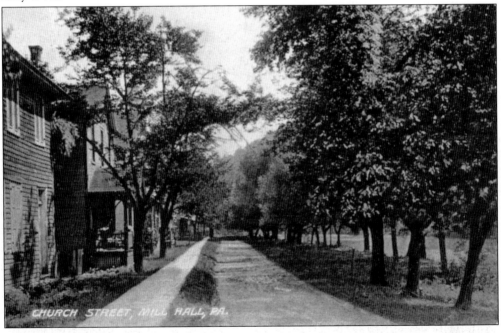

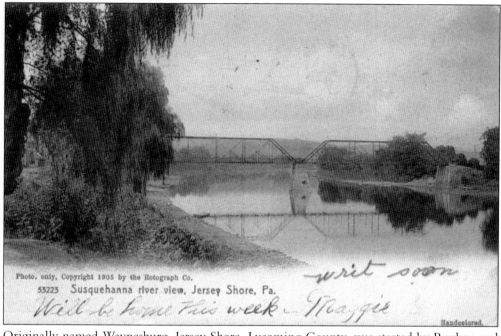

Photo. only, Copyright 1905 by the Rotograph Co.
53223 Susquehanna river view, Jersey Shore, Pa.
writ soon
Will be home this week - Maggie
Handcolored.

Originally named Waynesburg, Jersey Shore, Lycoming County, was started by Reuben and Jeremiah Manning, brothers from New Jersey, in 1785. A competing community across the river took to calling Waynesburg the "Jersey Shore" in reference to its founders' original home. In 1826, the town was incorporated as Jersey Shore. Pine Creek flows into the West Branch at Jersey Shore from the north. These two cards show a view on the West Branch (above) and at Pine Creek (below) at Jersey Shore.

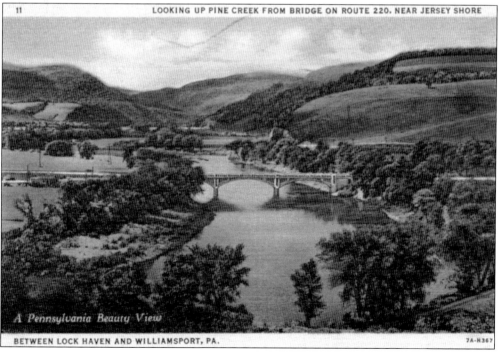

11 LOOKING UP PINE CREEK FROM BRIDGE ON ROUTE 220, NEAR JERSEY SHORE

A Pennsylvania Beauty View

BETWEEN LOCK HAVEN AND WILLIAMSPORT, PA. 7A-H367

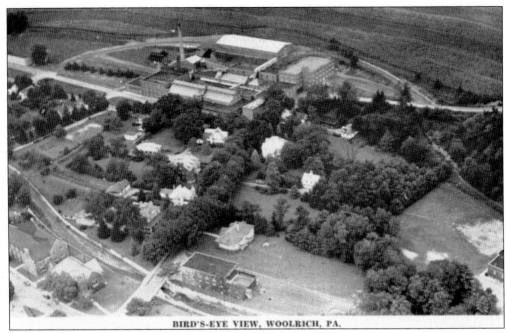

BIRD'S-EYE VIEW, WOOLRICH, PA.

Woolrich, Clinton County, is located on the north side of the West Branch of the Susquehanna River halfway between Lock Haven and Jersey Shore. In 1845, John Rich moved his wool business to the area that was first named Richville but would become Woolrich in 1888. The company made wool blankets during the Civil War and later expanded into leisure clothing. These postcards show an aerial view of the Woolrich plant and the Rich family home in Woolrich.

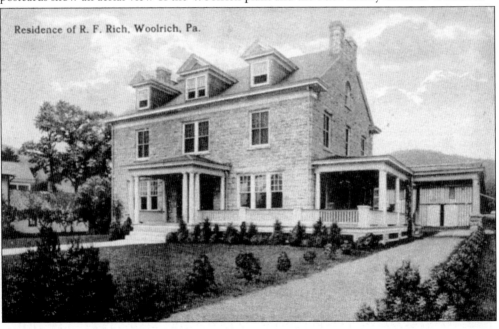

Residence of R. F. Rich, Woolrich, Pa.

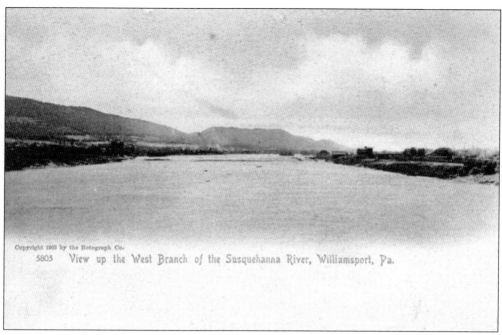

Copyright 1905 by the Rotograph Co.
5805 View up the West Branch of the Susquehanna River, Williamsport, Pa.

The West Branch of the Susquehanna flows east to Williamsport, the city that once received most of the lumber cut in and around the Bucktail Highway farther west. Williamsport is the seat of Lycoming County and was incorporated as a borough in 1806 and as a city in 1866. These cards show a view of the West Branch at Williamsport (above) and a busy Market Square in the city (below), both from the early 1900s.

MARKET SQUARE LOOKING WEST, WILLIAMSPORT, PA.

Log boom on the Susquehanna River at Williamsport, Pa. Hattie my Lately.

Williamsport was the lumber capital of the world in the late 1800s, primarily because it was on the receiving end of the lumber cut upstream. The Susquehanna Boom Company was formed in 1846 with the goal of establishing a boom or floating barrier at Williamsport to collect logs transported downstream. Fees were charged for storing logs in the boom and for hauling them out. These cards show the boom at Williamsport with the timber cribs linked by a chain that held the logs.

Susquehanna Boom, Susquehanna River, Williamsport, Pa. 1908

BIBLIOGRAPHY

Centennial Souvenir Program, Ridgway, Pennsylvania. Ridgway, PA: 1924.

Commonwealth of Pennsylvania, Department of Health. *Report on the Sanitary Survey of the Allegheny River Basin.* Harrisburg, PA: W. Stanley Ray, State Printer, 1915.

Daily Press. *Reflections of St. Marys.* Marceline, MO: Heritage House Publishing, 2001.

Day, Sherman. *Historical Collections of the State of Pennsylvania.* Philadelphia: George W. Gorton, 1843.

Donehoo, George P. *A History of the Indian Villages and Place Names in Pennsylvania.* 1928. Reprint, Lewisburg, PA: Wennawoods Publishing, 1999.

Egle, William H. *History of the Commonwealth of Pennsylvania.* Philadelphia: E. M. Gardner, 1883.

Hughes, Helen. *Lumbering in Elk County.* Ridgway, PA: Elk County Historical Society.

McGeehan, Dennis. *St. Marys.* Charleston, SC: Arcadia Publishing, 2006.

Stranahan, Susan Q. *Susquehanna: River of Dreams.* Baltimore, MD: Johns Hopkins University Press, 1993.

Taber, Thomas T., III. *The Goodyears: Empire in the Hemlocks.* Logging Railroad Era of Lumbering in Pennsylvania, No. 5. Muncy, PA: self-published, 1971.

———. *Sunset Along Susquehanna Waters.* Logging Railroad Era of Lumbering in Pennsylvania, No. 4. Muncy, PA: self-published, 1972.

———. *Tanbark, Alcohol, and Lumber.* Logging Railroad Era of Lumbering in Pennsylvania, No. 10. Muncy, PA: self-published, 1974.

———. *Whining Saws and Squealing Flanges.* Logging Railroad Era of Lumbering in Pennsylvania, No. 6. Muncy, PA: self-published, 1972.

Treese, Lorett. *Railroads of Pennsylvania.* Mechanicsburg, PA: Stackpole Books, 2003.

Van Diver, Bradford B. *Roadside Geology of Pennsylvania.* Missoula, MT: Mountain Press Publishing Company, 1990.

Wallace, Paul A. W. *Indian Paths of Pennsylvania.* Harrisburg, PA: Pennsylvania Historical and Museum Commission, 1998.

Weissman, Alice L. *A History of Elk County, Pennsylvania.* Ridgway, PA: Elk County Historical Society, 1981.

Weissman, Alice L., and Harriet Faust. *A Sesquicentennial History of Ridgway.* Ridgway, PA: Ridgway Publishing Company, 1974.

Williams, Oliver P. *County Courthouses of Pennsylvania: A Guide.* Mechanicsburg, PA: Stackpole Books, 2001.

Works Progress Administration. *Pennsylvania: A Guide to the Keystone State.* New York: Oxford University Press, 1940.

ACROSS AMERICA, PEOPLE ARE DISCOVERING SOMETHING WONDERFUL. *THEIR HERITAGE.*

Arcadia Publishing is the leading local history publisher in the United States. With more than 3,000 titles in print and hundreds of new titles released every year, Arcadia has extensive specialized experience chronicling the history of communities and celebrating America's hidden stories, bringing to life the people, places, and events from the past. To discover the history of other communities across the nation, please visit:

www.arcadiapublishing.com

Customized search tools allow you to find regional history books about the town where you grew up, the cities where your friends and family live, the town where your parents met, or even that retirement spot you've been dreaming about.

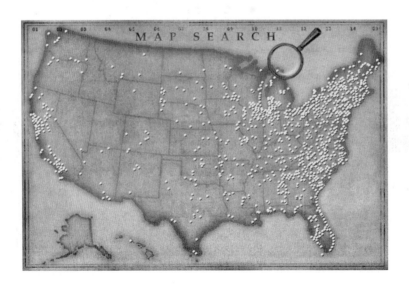